IMAGES
of America

GREENLAWN
A LONG ISLAND HAMLET

IMAGES
of America

GREENLAWN
A LONG ISLAND HAMLET

Louise Dougher and Carol Bloomgarden

ARCADIA
PUBLISHING

Copyright © 2000 by Louise Dougher and Carol Bloomgarden
ISBN 978-0-7385-0456-8

Published by Arcadia Publishing
Charleston, South Carolina

Printed in the United States of America

Library of Congress Catalog Card Number: 00106404

For all general information contact Arcadia Publishing at:
Telephone 843-853-2070
Fax 843-853-0044
E-mail sales@arcadiapublishing.com
For customer service and orders:
Toll-Free 1-888-313-2665

Visit us on the Internet at www.arcadiapublishing.com

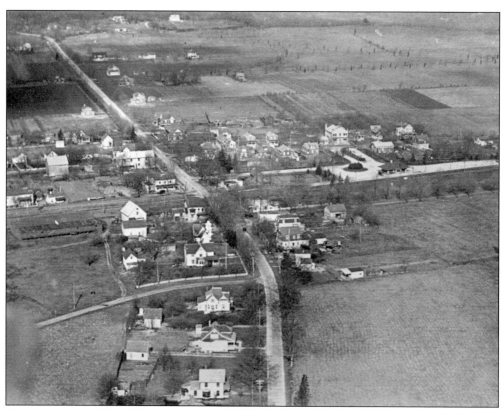

This aerial view of Greenlawn was taken in 1922.

CONTENTS

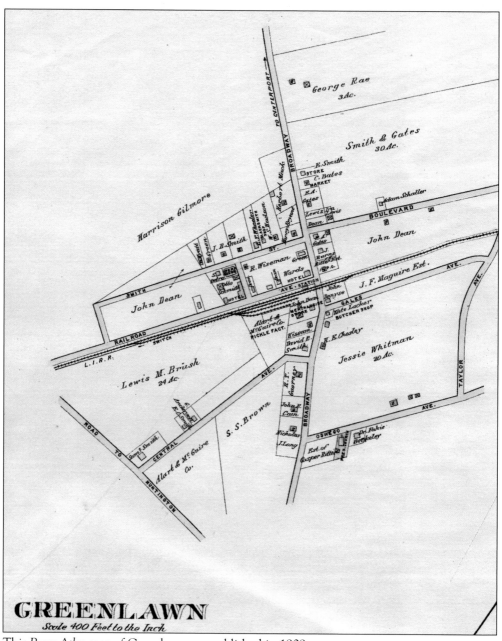

GREENLAWN
Scale 400 Feet to the Inch

This *Beers Atlas* map of Greenlawn was published in 1909.

INTRODUCTION

The hamlet of Greenlawn is in the town of Huntington, located on the north shore of Suffolk County, Long Island. Greenlawn was part of the "First Purchase" of land from the Matinicock Indians, recorded in 1653. Situated on fertile upland plains, the area, then known as "East Fields" and later as "Oldfields," served for more than 100 years as pastureland for the livestock of the first settlers of Huntington.

In the mid-1700s, land in Oldfields was allotted for settlement. The 1783 census records 12 families living there, including branches of the Smith, Conklin, Ireland, Willis, Lysaght, Wicks, Dennis, Jarvis, and Vail families. In the early 1800s, other farm families, mostly from Huntington, settled at Oldfields. They included the Baylis, Brush, Burr, Gardiner, Tilden, Rogers, Whitman, Kissam, and other Smith families. These early settlers farmed large tracts of land.

In 1868, the extension of the Long Island Rail Road (LIRR) east from Huntington through the sparsely settled farmlands at Oldfields spurred the growth of the area. The station at Oldfields was named "Centreport," since it was meant to serve the residents of that shore village a mile and a half to the north. However, even before the depot was completed, William Smith, the farmer who owned the land where the depot was to be located, began selling plots of land for businesses and homes. Soon, a little community grew around the depot and developed its own identity. The depot name was changed to Greenlawn-Centreport and then to Greenlawn.

The railroad made the rapidly growing New York City markets easily accessible to local farmers and changed the farm economy. Instead of self-sufficient farming, farmers could sell surplus crops and purchase flour, soap, cloth, and factory-made household items. In Greenlawn, Alexander Gardiner promoted the planting of pickles (cucumbers less than 4 inches in length) and cabbage as cash crops. Processing plants were opened beside the railroad tracks.

The LIRR promoted Greenlawn and other villages as part of a turn-of-the-century campaign to stimulate business by attracting both summer visitors and home buyers to Long Island. A 1902 publication by the LIRR Passenger Department stated, "Greenlawn . . . is a rural village . . . tucked away in one of the most picturesque parts of the hills . . . an ideal and inviting spot." Vacationers came and many remained, building homes and establishing businesses in the community. With the completion of the East River tunnels and the opening of Pennsylvania Station in 1910, it became feasible to work in the city and live in Greenlawn.

In the 1950s and 1960s, large-scale development occurred. Many of the old farms were sold to developers and subdivided for housing. Fountainvale and Robin Park were built on the old Alexander Gardiner farm, Carriage Hill on the George William Smith property,

the Salem Ridge Development on the former farm of Orlando Baylis, and Crown Estates on Walter Brush's land.

Today, the old farms are gone, but Greenlawn is an attractive, vibrant suburban community. It is located close to Long Island Sound, where residents enjoy boating and swimming. Interesting old houses, an old-fashioned main street, excellent schools, a fine library, an active historical association, and a committed civic association make Greenlawn a good place to live.

Authors' Note

The content of this book was determined by the photographs that members and friends have generously donated to the Greenlawn-Centerport Historical Association over the years.

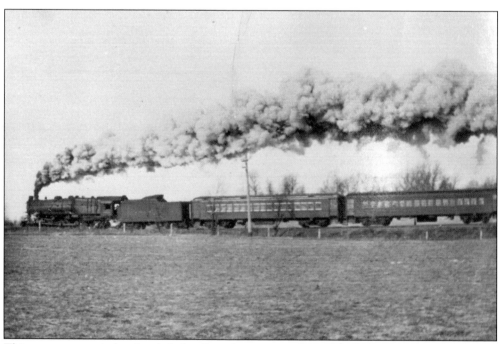

This commuter train has just left the Greenlawn station bound for Jamaica.

One

THE FARMS

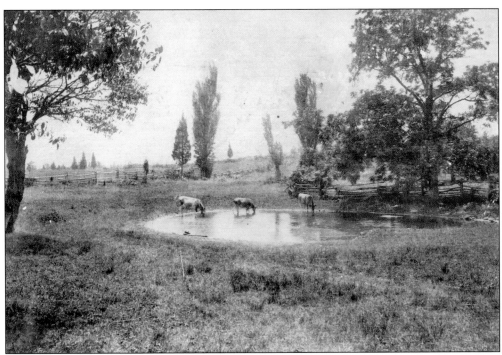

Before the 1870s, the farmers of Oldfields worked large tracts of land and were self-sufficient, producing almost everything they needed for their families and for their livestock. When the Long Island Rail Road came through in 1868, the farm economy changed. With city markets now easily accessible, farmers could grow surplus products to sell. Pickles and cabbage became the most important cash crops.

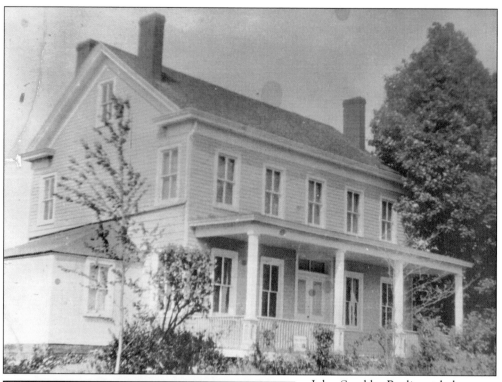

John Scudder Baylis settled in Oldfields c. 1830, and his descendants lived on the family homestead until 1916. The large farm consisted of 225 acres west of Salem Ridge Drive, between Greenlawn Road and 25A. In 1866, John's son Orlando built this fine Federal-style farmhouse for his bride, Elizabeth Miner. This photograph was taken c. 1910.

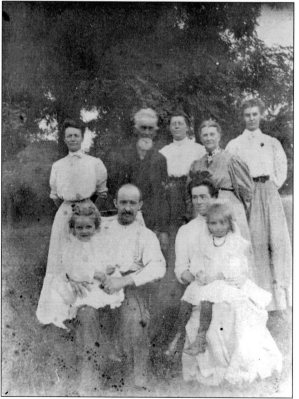

Shown at this Orlando Baylis family gathering are, from left to right, the following: (front row) Edith Horton, Walter Duryea, Mildred Baylis, and Emma Baylis; (back row) Mrs. Duryea, Orlando Baylis, Carrie Baylis Horton, Mrs. Orlando Baylis, and Evelyn Baylis Cornwell.

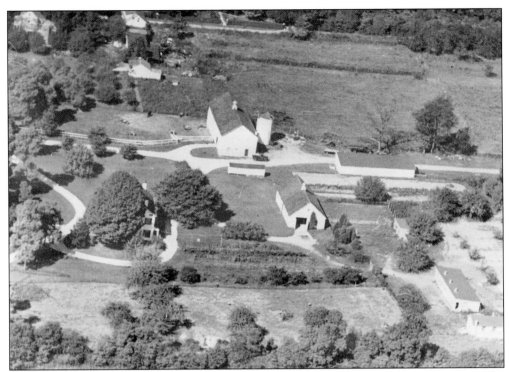

This aerial view of the Baylis farm was taken in 1954, when it was still a working farm. The farmhouse and outbuildings, including the cow barn, the chicken house, and the corncrib, can all be seen.

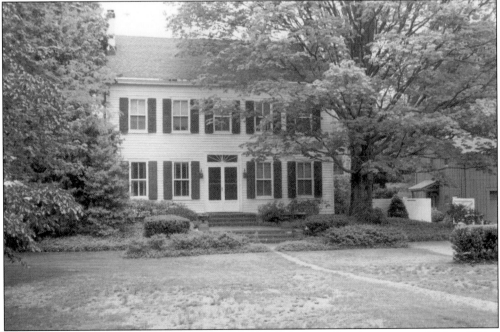

The Orlando Baylis farmhouse still stands at 115 Greenlawn Road, just west of Salem Ridge Drive. It is now the home of the James Campbell family.

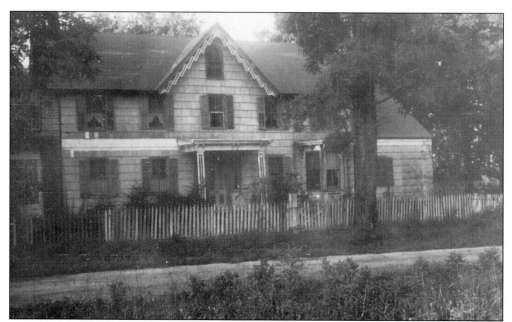

Adjoining the Baylis farm was that of Walter Brush, who moved to Oldfields from Huntington in 1835. His homestead encompassed the area between Renwick Avenue and Salem Ridge Drive, running north almost to 25A. This farmhouse, which was at the junction of Old Field and Greenlawn Roads, burned down in the late 1950s.

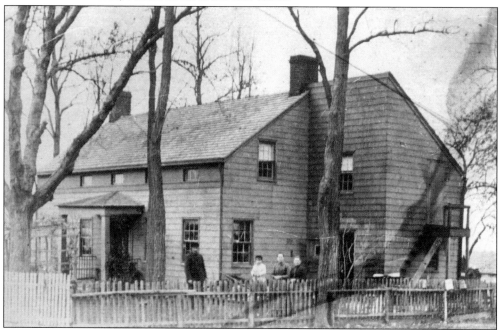

When Samuel Brush married Anna Ketcham, he acquired the large farm adjacent to Walter's that had been settled by his father, Thomas Brush, in 1835. The original part of the dwelling, distinguished by its five lay-on-your-belly windows, was built in the early 1800s. A west wing was added c. 1930, and an east wing was built c. 1950. Later, Dr. Walter Carpenter purchased the property. The house still stands on Old Field Road.

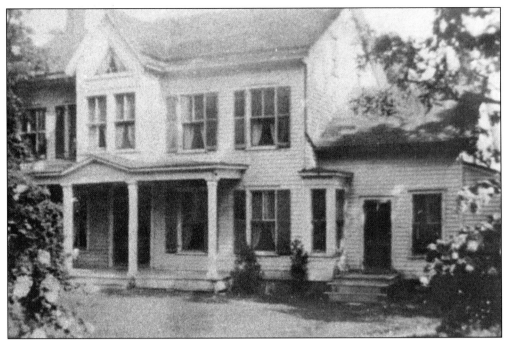

In 1867, Frederick Brush acquired the 196-acre farm across the road. In 1885, he built the farmhouse that stands today. Frederick sold off the east half of the farm along Broadway in 1904 and left the rest to his son, Selah. Selah and his wife, Angeline Smith, raised their five children, Russell, Helen, Selah Jr., Ethel, and Harold, on the farm. This photograph of the farmhouse was taken c. 1920.

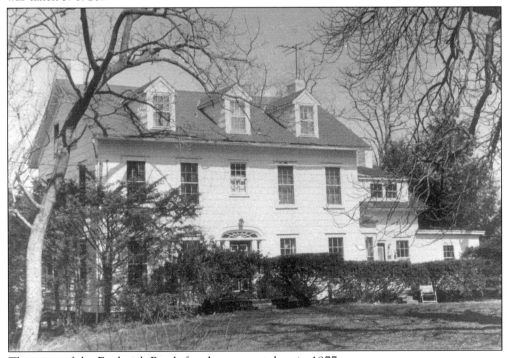

This view of the Frederick Brush farmhouse was taken in 1977.

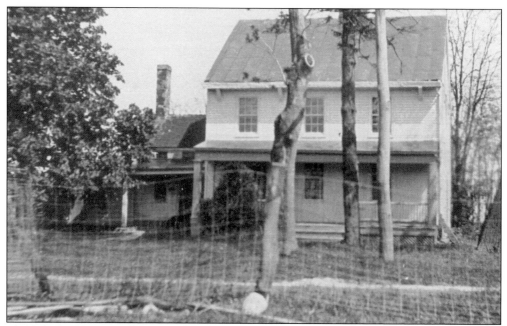

The home of George William Brush was situated at the curve of Greenlawn Road where it intersects with Dunlop Road. The original farmhouse was the small section on the left, built by the Conklin family, who occupied the farm from c. 1760 to 1835. The larger section was probably added c. 1851, when the George William Brush family moved there. The 162-acre property extended from Old Field Road, west of Tilden Lane, south almost to the railroad tracks.

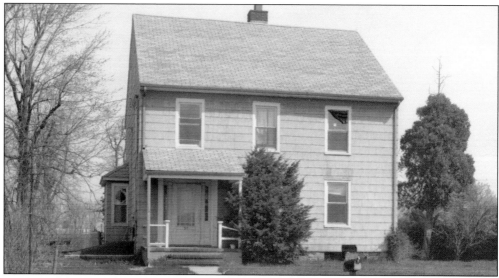

In 1918, Theodore Rowehl purchased the George William Brush farm. In the early 1950s, the Rowehls remodeled the farmhouse, removing the 18th-century wing and a porch. The house's stark appearance contrasted with its bucolic setting. Forty-four acres of the farm were sold to the Harborfields School District in 1964 as the site for Oldfield Middle School. The last 8 acres of the farm were sold in 1980, and three houses were built on the property. In the late 1990s, the farmhouse was expanded and completely remodeled by its new owners.

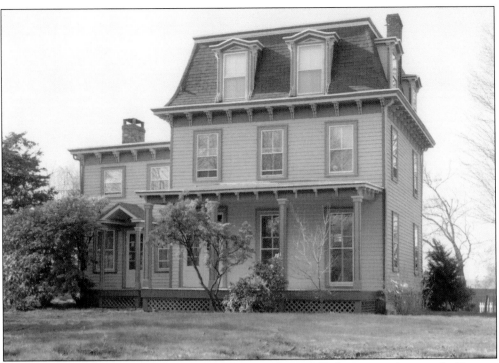

When George William Brush's son Luther married in 1863, he received as a gift 60 acres of his father's farm. There, he built the smaller section of this house, which still stands at 344 Greenlawn Road. In 1877, Luther sold the house to Divine Munger, who added the larger Victorian wing. In the early 1920s, when the two-room school across the road became overcrowded, the district rented the living room and parlor of the farmhouse for classroom space. In the late 1980s, Richard and Lorraine Miano restored the house to its original appearance and arranged for its listing on the National Register of Historic Places.

In 1884, Divine Munger built this charming small dwelling just across the road from his farmhouse. It was used to house the hired help. With its mansard roof, it was almost a replica of Mr. Munger's own farmhouse. In the 1990s, the house, which is also on the National Register of Historic Places, was enlarged. The same architectural style was maintained.

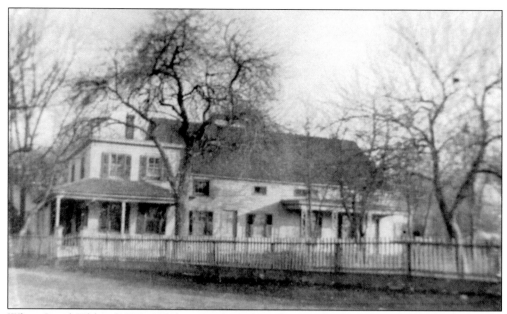

When Israel Tilden (1789–1878) married Sarah Oakes in 1812, he built the original (center) part of this house, pictured here, on his father's farm. His father, also named Israel, had come to Oldfields in 1793 as one of the early settlers and had purchased 60 to 70 acres of farmland around Tilden Lane from his father-in-law, Thomas Wicks. The wing on the right was added in 1865, and the flat-roofed section on the left was added in 1884, when Israel's son John married Anna Kissam. The house still stands on Tilden Lane.

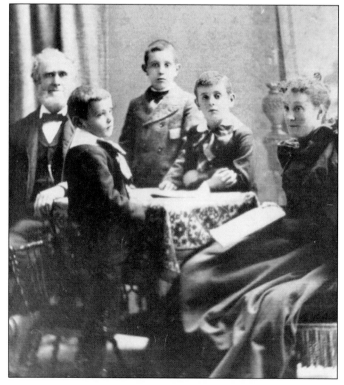

This formal portrait of the John Tilden family was taken in 1896. Shown are John; his wife, Anna Kissam; and their sons, Charles E. and twins Leroy and Raymond.

The original Charles Kissam farm comprised 184 acres, which extended along the east side of Broadway from north of the railroad tracks to near the top of Centerport Hill and from Broadway east to Taylor Avenue, East Maple, and Stony Hollow Road. After Charles's death, the land was divided among his children. In 1904, his son Elisha and his daughter Martha sold their sections of the farm to a real estate syndicate headed by Willard N. Baylis of Huntington. Baylis planned to develop the area as Cedarcroft Estates.

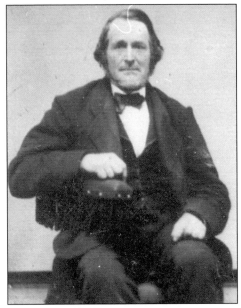

Charles Kissam (1813–1879) and his wife, Elizabeth Ireland Mott (1815–1898), settled in Oldfields in 1846. Although Charles was a sea captain, they raised their five children on their large farm at Oldfields. Charles sailed out of Centerport. His schooner plied the waters between Centerport and New York City. It carried lumber, flour, and farm products to the city and returned with goods ordered by local merchants and families. One frequent cargo was horse manure, gathered from the streets of New York City, for use as fertilizer on Greenlawn farms. The manure was unloaded at the Mill Dam in Centerport and left for farmers to cart away by horse and wagon. Charles Kissam died on his schooner in New York Harbor in 1879.

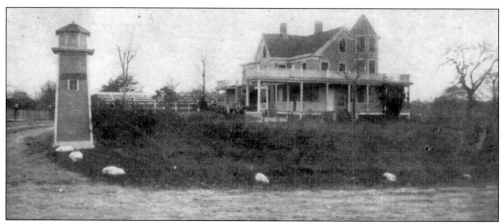

This rambling Queen Anne–style house, known as Tower Hill Farm, was built in the early 1900s as a summer home for Oscar and Sarah J. Sheffield of New York City. It was named for the many towers—both large and small—that were originally placed around the property. The house still stands behind tall hedges on the southeast corner of Dunlop and Lake Roads.

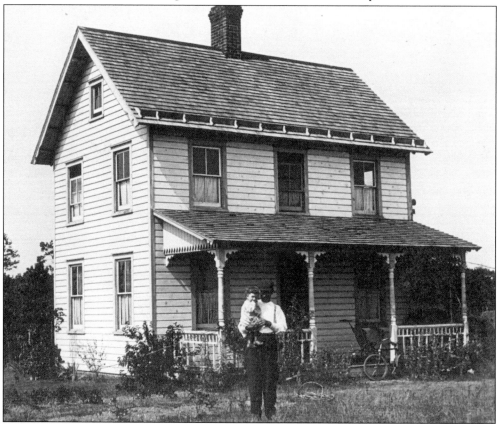

In this *c.* 1912 photograph, John BaRoss holds his son Joseph while his son Louis hides from the photographer in the right foreground. The house is oriented to the south for warmth and light, as was often the custom at the time; the back of the house faces the road. In 1977, this property at 62 Wells Road was purchased by Edward and Leona Ceglia. Now called Long Acres Farm, it is farmed as a nursery

This hilltop home of the Van Nostrand family on Stony Hollow Road is an attractive farmhouse that has been enlarged and remodeled over the years. The left wing, which was the original 1840 farmhouse, has 19th-century rafters with wooden pegs and hand-hewn beams. Outbuildings, including a barn, a hog house, and a root cellar, still stand on the property, now owned by the Maravell family.

This photograph shows Mrs. Benjamin (Sarah) Van Nostrand and her daughter Rosina. Mrs. Van Nostrand operated the "Van Nostrand Farm House," which advertised accommodations for 15 guests. In 1900, adult rates ranged between $7 and $8 per week.

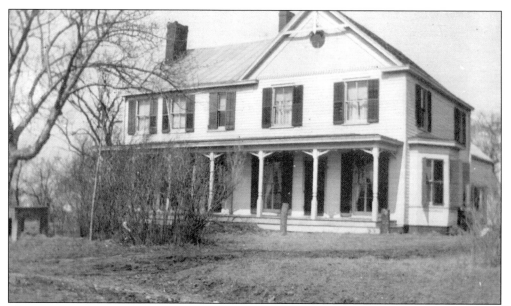

The William Wightman family came to Greenlawn from New York City in 1886 and occupied the *c.* 1880 farmhouse across the lane from the Presbyterian church. William's son Mark farmed the land, worked as a contractor, owned a livery stable, and was a charter member of the Greenlawn Fire Company. The farmhouse was torn down *c.* 1960, and two housing developments—Green Oaks and Harborfields Estates—were built on the farm property.

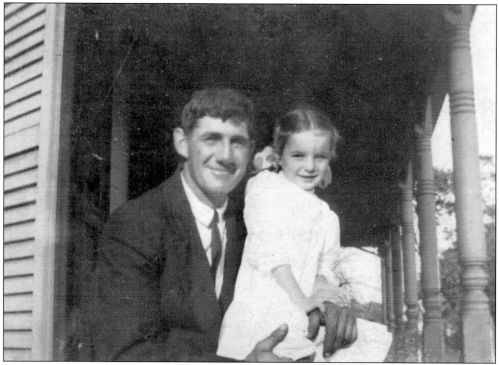

Mark Wightman, son of William Wightman and Jennie Rae, poses with his niece, Emily Wightman, on the porch of his farmhouse, *c.* 1910.

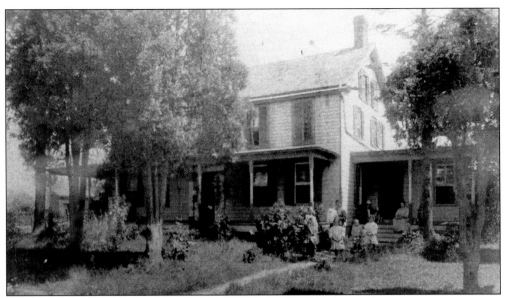

George William Smith built this farmhouse in 1862. The farm of George William and his father, William, included land from Cuba Hill and Clay Pitts Roads, north to the railroad tracks. The farmhouse and surrounding acreage was acquired in the early 1900s by Otto Schmidt, who sold it in 1924 to Ralph Dodge. In 1948, the property was purchased by Fred Bartel. He tore down the old farmhouse and replaced it with the brick house that still stands at 130 Broadway. In the early 1960s, the property was sold to a developer who constructed the Carriage Hill homes on the site. Pictured on the porch of the old farmhouse in 1908 are members of the Eppinger family.

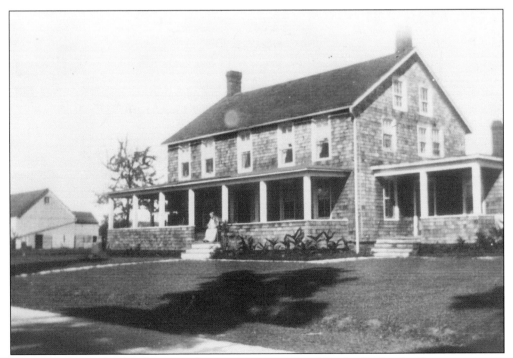

This view shows the farmhouse at the time it was occupied by the Dodge family.

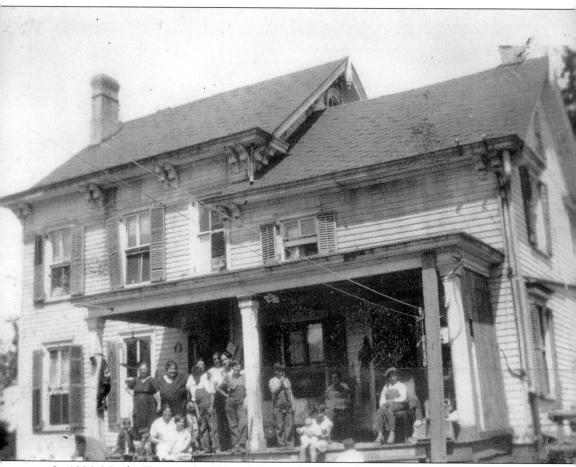

In 1906, Martha Townsend sold her 200-acre farm to real estate developer Frederick Kampfe of New York. The original part of the farmhouse was erected c. 1840, with the taller section added later. From 1927 to 1936, the Joseph DeRiso family lived in the house and farmed the remaining 45 acres. Members of the extended DeRiso family are shown on the back porch of the farmhouse in this c. 1930 view.

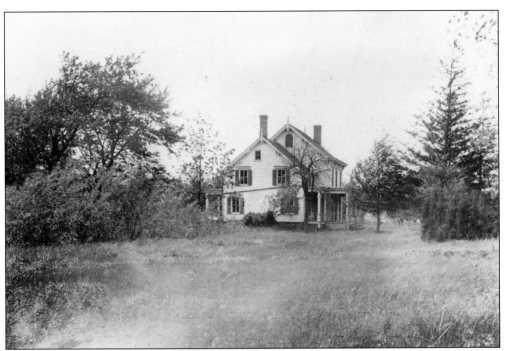

This side view shows the DeRiso house, c. 1930.

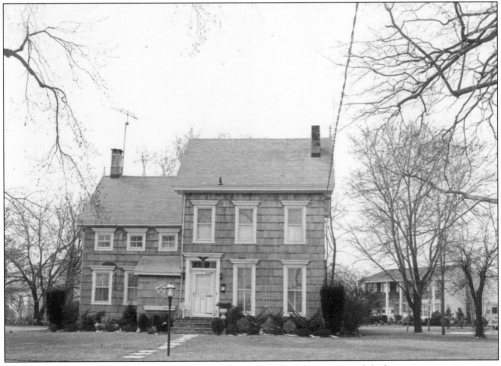

This photograph was taken in 1977, after the house had been remodeled.

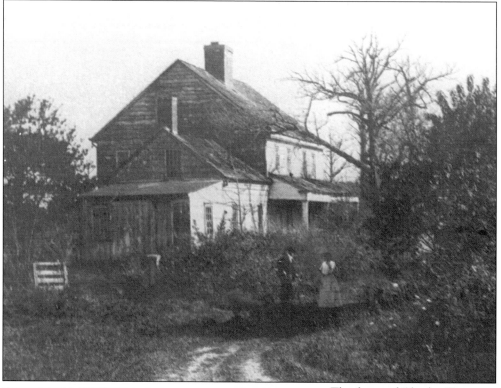

The farms of Charles Duryea Smith and his father, Eliphalet Smith, were contiguous and were bounded by Lake Road on the east, Dunlop Road on the north, the LIRR tracks on the south, and Park Avenue on the west, with a few additional acres on the west side of Park Avenue near the railroad tracks. Eliphalet's farmhouse was located south of Dunlop Road and to the west of Lake Road. This photograph shows the farmhouse and the lane that connected the homes of father and son.

This picturesque view shows children opening a gate on the farm lane connecting the farms of Eliphalet and Charles.

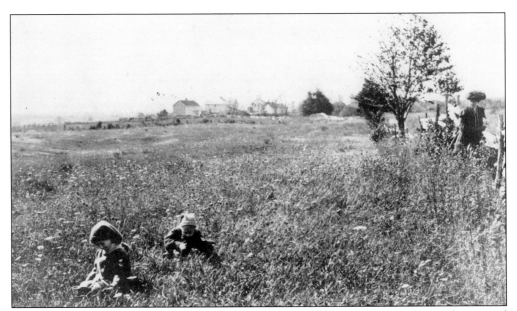

These children are picking flowers in the fields of Charles Duryea Smith. His house and outbuildings are shown in the background. The lane on the right leads to the farmhouse of Eliphalet Smith, Charles's father.

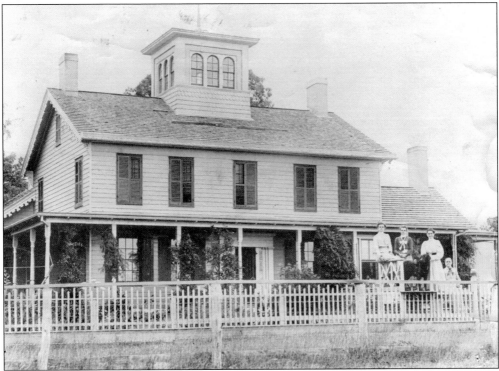

Shown on the horse block in front of the Charles Duryea Smith farmhouse, which was located on Park Avenue north of the railroad tracks, are three generations of Smith women: Mary Angeline Sammis Smith, Charles's wife; their daughter, Phoebe Smith; and granddaughters, Angeline and Carrie. The photograph was taken c. 1900.

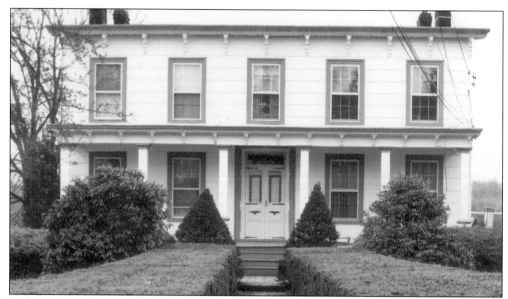

Built *c.* 1860, this Italianate-style farmhouse of the Makinajian family at 276 Cuba Hill Road remains virtually unaltered. Little is known about its early inhabitants, but old maps indicate their name was Ackerly. In 1948, Joseph Makinajian purchased the property and started an egg route. The Makinajian family now operates a poultry business and are certified organic growers of fruits and vegetables. Customers enjoy the ducks, geese, sheep, the pony, and other farm animals kept as pets.

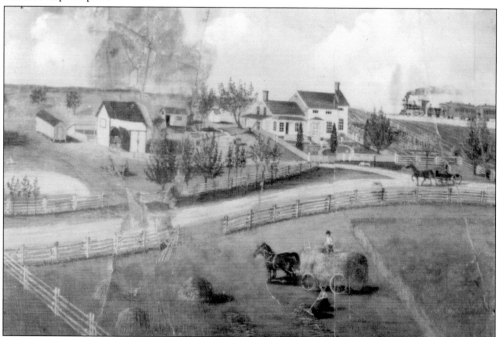

The Greenlawn-Centerport Historical Association recently acquired this 1880 Edward Lange painting from May Gardiner Schneider. It portrays the farm of Alexander Gardiner's brother Charles. The farm was located west of Park Avenue on the south side of the Long Island Rail Road tracks.

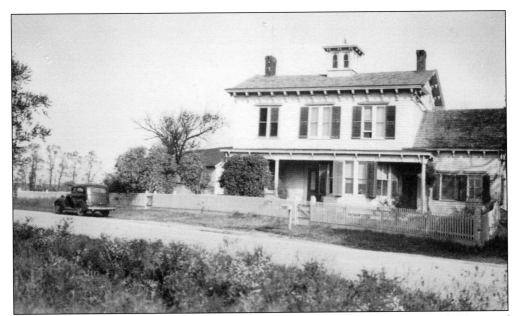

The Smith-Gardiner farmhouse at 900 Park Avenue, which is listed on the National Register of Historic Places, was probably built by Henry Smith (1729–1802) at the time of his marriage in 1752. His granddaughter Fannie (1803–1886) married Joel Bunce Gardiner (1800–1849); their son Alexander Gardiner grew up in the house. Alexander's grandchildren, the children of John Gardiner, Alice (1896–1985) and the twins, Herbert (1902–2003) and Harold (1902–1982), were born in the farmhouse, never married, and never lived anywhere else.

This formal portrait of Alice and her twin brothers, Herbert and Harold, was taken in 1906. It hangs in the parlor of the Smith-Gardiner farmhouse.

Alice Gardiner is pictured here in 1982.

Herbert Gardiner, age 95, rests from his farm chores beneath the shade of a tree.

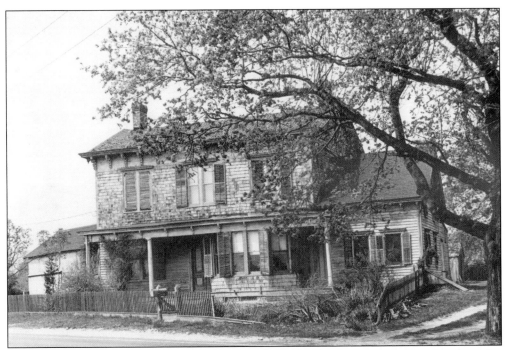

The original c. 1750 farmhouse is the one-and-a-half-story frame structure shown on the right. It was enlarged and remodeled in the 1860s by Alexander Gardiner for his mother, Fannie, in the vernacular Italianate style with some Colonial features. Of special interest are the interior end chimneys, the eaves with elaborate brackets, the deep cornice moldings over windows, and the quadrant windows in the gable ends. Except for the first-floor bay window that was added after 1910 and the cupola removed in the 1950s, the house has stood virtually unchanged, inside and out, for well over a century.

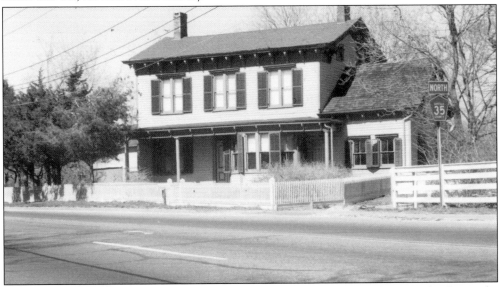

In the late 1990s, the exterior of the Smith-Gardiner house was painted in period colors and a few necessary repairs were made. The original outbuildings—including a barn, a smokehouse, an outhouse, a workshop and tool shed, a chicken coop, and a pigpen—were stabilized.

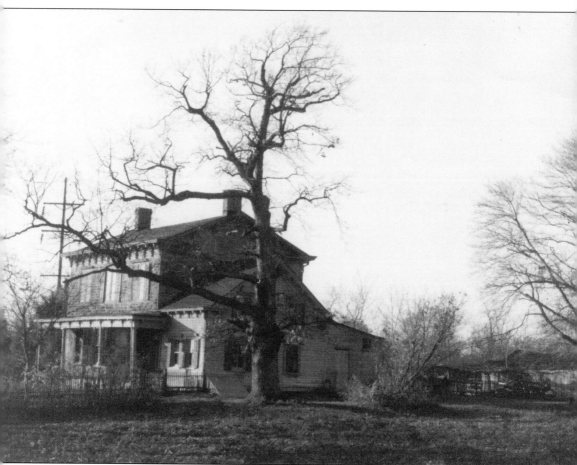

The Smith-Gardiner farmhouse was the scene of a sensational murder in 1842. As reported in the *Long Islander* newspaper, the "gruesome murder" of Mr. Alexander Smith and his wife took place at their Park Avenue home on Sunday, November 13, 1842. Their bodies were not discovered until the following morning. The murder suspect was a farmhand, Antoine Keisler, who planned to kill and rob the Smiths and then burn the house to destroy all evidence. However, he became alarmed before he could search for valuables and made a quick escape through a rear window. Keisler was apprehended in Port Jefferson. He was tried, convicted, and eventually hanged. Mourners from near and far attended the funeral services for the Smiths. Mr. Smith was well known as a worthy and wealthy farmer.

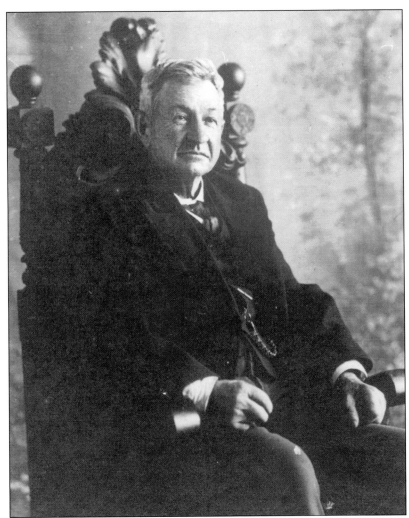

Alexander Gardiner was born on March 4, 1835, in the Huntington area. After the murder of his maternal grandparents in 1842, the Gardiner family moved to the Smith-Gardiner farmhouse where the grandparents had lived. Alexander's father died when he was 14 years old; Alexander then assumed major responsibilities on the farm.

In 1858, Alexander married Elizabeth Jarvis and established a home and farm north of the Smith-Gardiner farmhouse. Over the years, Alexander purchased additional farmland until his holdings reached 600 acres, extending south of Park Avenue and Lake Road and north beyond the LIRR tracks to Dunlop Road. Alexander had many interests beyond farming. He built and operated a large cider mill, a sawmill that furnished wood for local shipbuilders, a brickyard on Long Island Sound, a gristmill, and an icehouse. He built pickle-processing plants that he leased and had his own freight depot, from which products were shipped to New York City markets. He developed Green Prolific Pickle Seeds, which he sold along with various fertilizers, pesticides, the latest farm machinery, and wagons. In time, he also had an automobile dealership.

After Alexander died in 1914, most of his land was divided among his three surviving sons, John, William, and Egbert. In 1953, the farmhouse burned. Subsequently, the Gardiner property south of Pulaski Road was sold to developers. The homes of Fountainvale and Robin Park now occupy part of the tract that was once the Gardiner farm. This portrait of Alexander Gardiner was taken in 1912.

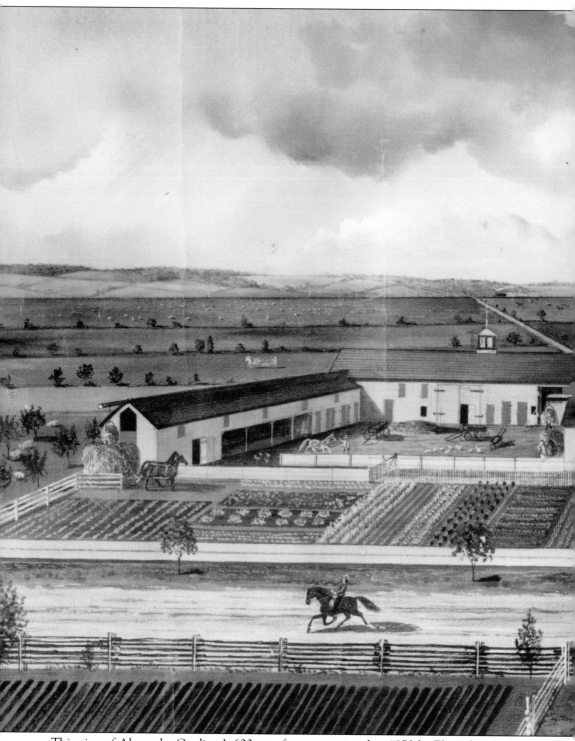

This view of Alexander Gardiner's 600-acre farm was painted in 1873 by Elwood artist Edward Lange. The attractive farmhouse, the extensive barns, the carefully cultivated gardens, the lush fields, the pastures, and the orchards attest to Gardiner's skill at farming and to his wealth and

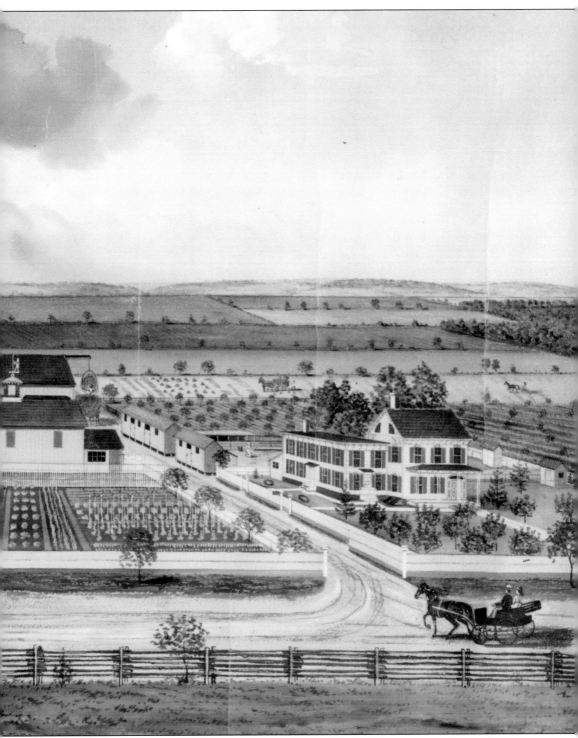

success. The north-south road leads to Gardiner's own freight depot. A passing train can be seen in the distant background.

Alexander Gardiner built this gable-roof, clapboard-sided "cottage" at 863 Lake Road c. 1912. After Alexander's son Egbert died in 1923, his wife, Elizabeth Colyer Gardiner, and four children moved into the house. Alexander had willed it to their only son, Leroy, who lived in the cottage and actively farmed the land until his death in 1980. The house and some of the land were then sold and condominiums were built along the shore of Gardiner's Lake. This photograph was taken in 1918.

This saltbox-style house on Lake Road is one of the oldest extant dwellings in Greenlawn. It was built by Jacob Ireland c. 1775, when he married Elizabeth Kelsey. Later, it was occupied by their son Walter and grandson Jacob. In 1868, the Ireland property was acquired by Alexander Gardiner. The photograph shows the house c. 1975.

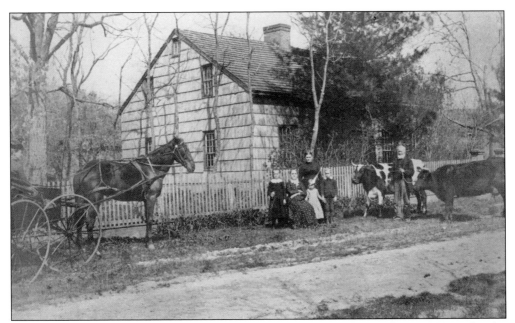

This early homestead reflects both Dutch and English architectural influences. By 1858, the Smith Whitson family lived there. In this early photograph, Mr. Whitson stands by the cows and his wife, Phoebe Platt, sits. Standing behind the grandchildren is their daughter Abbie, who married Mordant Smith. Their daughter Hattie was the mother of Ethel Suydam Witting, a charter member of the Greenlawn-Centerport Historical Association. In 1903, William Godfrey leased the farm. The house, changed somewhat over the years, still stands with its outbuildings at the junction of Godfrey Lane and Little Plains Road.

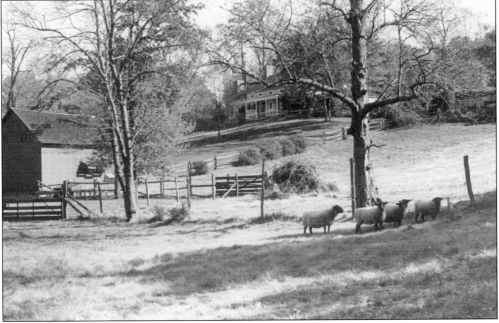

This pastoral scene, taken in 1977, shows sheep grazing on the front lawn of the Rhemp-Smith house located across the road from the Smith Whitson farm.

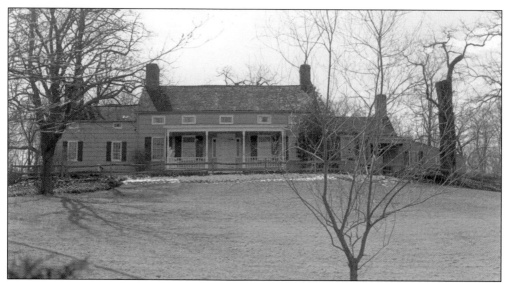

The Rhemp-Smith house at 42 Godfrey Lane was the centerpiece of a large farmstead, extending west along Little Plains Road to Broadway and some distance south. The earliest section of the house is the west wing, built *c.* 1770 by Michael Rhemp. The main house and the east wing were added *c.* 1830. Since that time, there have been no structural changes, and the house, which is on the National Register of Historic Places, appears today as it did then. Michael Rhemp's granddaughter, Phoebe, married Henry Smith in 1831; the house remained in the Rhemp-Smith family until 1903, when Michael Rhemp's great-grandson, Joel Barnum Smith, retired from farming and moved to Greenlawn village.

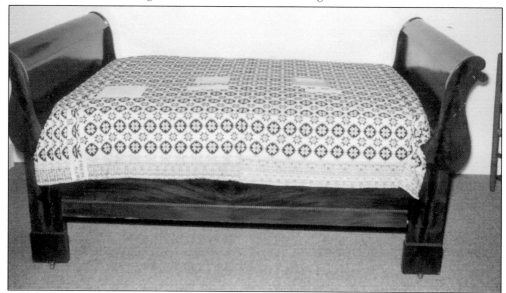

This blue and white reversible coverlet was woven for the hope chest of Phoebe Rhemp. Woven into one corner of the coverlet is her name and into another corner the date, February 12, 1824. Handed down from generation to generation in the Rhemp-Smith family, the coverlet, together with this 19th-century sleigh bed, were taken to London by their last owner. In 1995, descendants returned these items to Greenlawn, donating them to the Greenlawn-Centerport Historical Association.

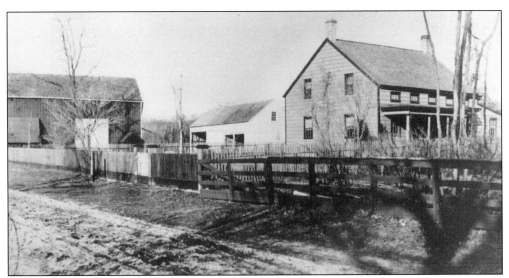

Located on the east side of Manor Road, north of Jericho Turnpike, is this farmhouse and barn that John Robertson built in the early 1800s. His son, Burtis, inherited the farm and lived there until 1903. For many years, a cider mill operated in the cellar of the barn and the property was known as Cider Mill Farm. In 1952, the Joseph Becker family purchased the property and named it Manor Farm. They raised squab for market and kept many domestic and exotic birds and animals. Their gaggle of geese, accompanied by the Becker children, were often featured in parades. In 1999, Huntington Town purchased the farm as part of its Open Space Program.

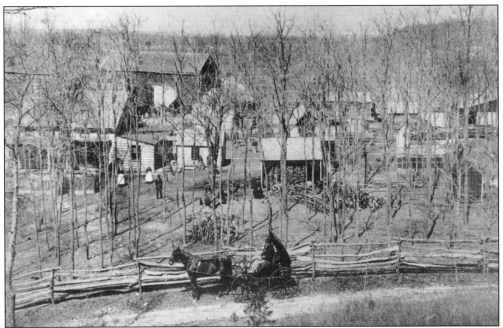

This c. 1890 panoramic view of the Robertson farm shows the family, the farmhouse, and the numerous outbuildings typically found on farms of the period, including the barns, the corncrib, the pigpens, the chicken house, and the woodshed. To obtain this view, the photographer was probably perched atop the farm's water tower.

GREENLAWN

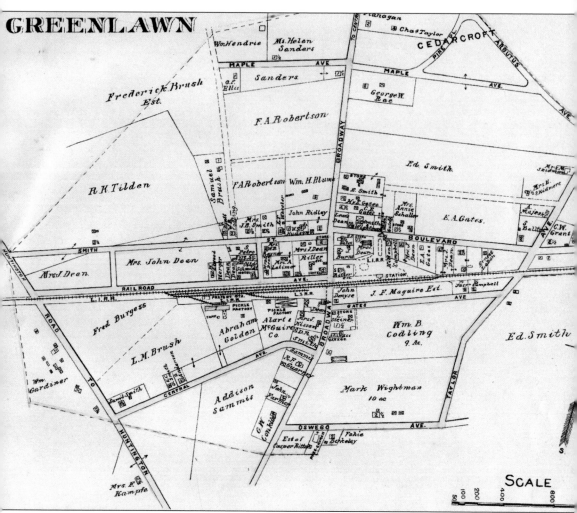

Beers Atlas published this map of Greenlawn in 1917.

Two

THE HOMES

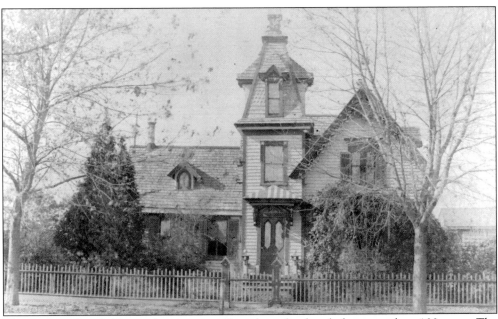

The Seabury Smith Kissam house was a Greenlawn landmark for more than 100 years. The charming, Carpenter Gothic–style dwelling was built by George Brown in 1870 on Broadway, just south of the general store. Seabury and his family moved to the house c. 1882, and descendants continued to live there for almost 90 years. In 1972, the house was torn down and replaced by a Friendly's Restaurant, which closed in 1997.

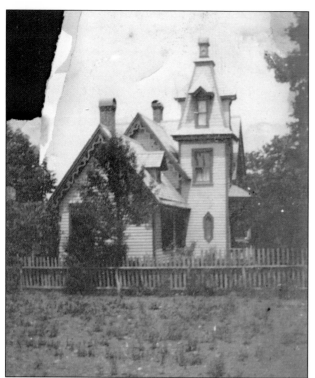

This view shows the south side of the Seabury Smith Kissam house *c.* 1890.

Seabury Smith Kissam (1837–1908) and his wife, Josephine Denton (1841–1923), raised ten children in their Greenlawn home. Seabury worked at various times as a stagecoach driver, a mail carrier, a Long Island Rail Road station agent, and a builder of carriages. He was a charter member of the Columbia Hook and Ladder Company. Shown in this family portrait are, from left to right, the following: (front row) Elliot, Agnes, Eugene, Ella, Charles, and Hazelle; (middle row) Daniel, Seabury, and Josephine; (back row) William, Ida, and Frank.

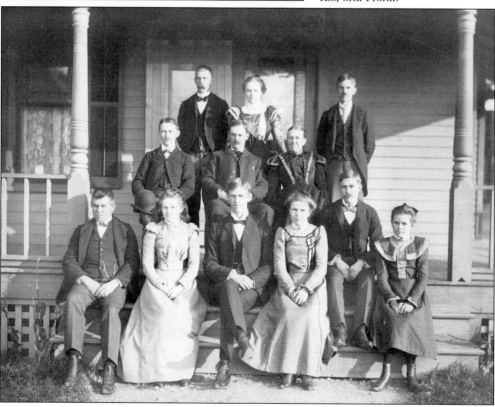

This house was built in 1896 by Henry Israel Smith, who was then proprietor of the general store. In 1904, the house was sold to David R. Smith and his wife, Annie Gates, who lived there the rest of their lives. In this c. 1905 picture, Mrs. Smith stands on the porch and Mr. Smith is in the yard. The Smiths' son Earle continued to live in the house until he died in 1948. Unoccupied for several years, the house was torn down in 1970, and a Citibank office, now closed, was built on the site.

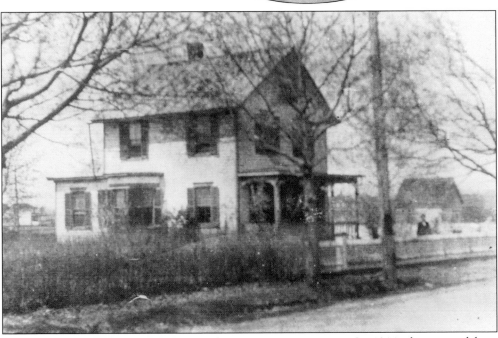

The Farmer family first came to Greenlawn as summer visitors. In 1914, they moved here permanently, purchasing this house from John Cairns, a vaudevillian. The Farmer sisters, Agnes and Alice, lived there until the 1960s, when they bought a new home in the Carriage Hill development. Alice, an English teacher and a guidance counselor, wrote her recollections of life in Greenlawn for the historical association. The Farmer house still stands at 105 Broadway.

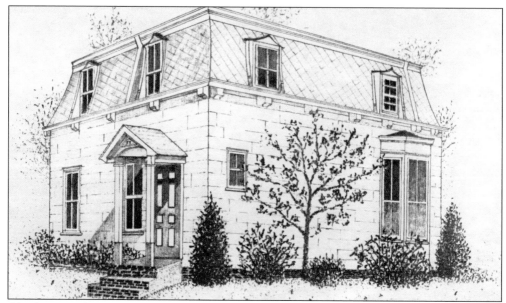

The first members of the Gates family to live in Greenlawn were probably Henry Gates and his wife, Martha S. Oakes. Their home was located on Broadway and Grafton Street, where Dairy Barn now stands. A son, Edward, operated a butcher shop on the corner of Broadway and Gates Street. In 1887, he built this attractive mansard-roof house next to his business. In 1985, the house was offered to the Greenlawn-Centerport Historical Association when Irving Fox, owner of Fox's Paints in Greenlawn, purchased the property with plans to build a new paint store there. Despite efforts to move the house to Huntington Town property and restore it for association headquarters, the plan ultimately proved unfeasible and the building was demolished in April 1986. This drawing was made by Bob Teufel at that time.

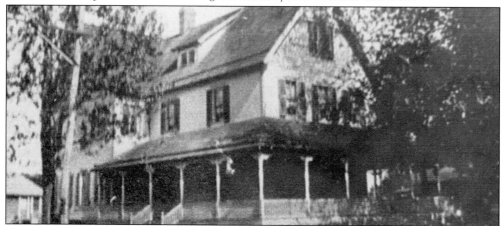

Ed Gates and his wife, Eugenia Nifenecker, had 11 children. In 1906, the family moved to a larger home on the southeast corner of Broadway and Boulevard. Built by William Beatty in 1896, it had been a hotel and contained a grand ballroom. Ed turned the hotel into a private home for his large family. Unfortunately, Eugenia died that same year, but Ed continued to live in the house with his younger children until c. 1917. Ed sometimes used the ballroom for parties, dances, and weddings. After the building was torn down c. 1920, stores were constructed on the site. Several of Ed's children built homes in Greenlawn and many Gates descendants live here today.

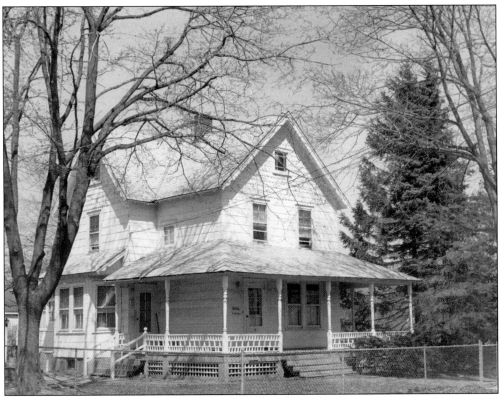

Sometime between 1894 and 1900, Samuel Ballton built this house at the northeast corner of Smith Street and Gaines Avenue. He lived in it until he sold it to Joel Barnum Smith in 1903. Later, it was the home of the Homer Pierson family. Mr. Pierson served at various times as a station master, a postmaster, and a justice of the peace. In 2000, the house was remodeled, modernized, and considerably enlarged.

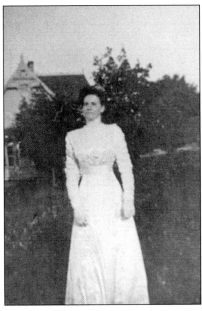

Above: The house featured clamshell shingles in the gable ends and some nice Victorian detailing. *Right:* Grace Pierson poses in the yard in her wedding gown on January 12, 1909, the day she became the bride of Charles Tilden. Ethel Wyckoff, a longtime member of the Greenlawn-Centerport Historical Association, is their daughter.

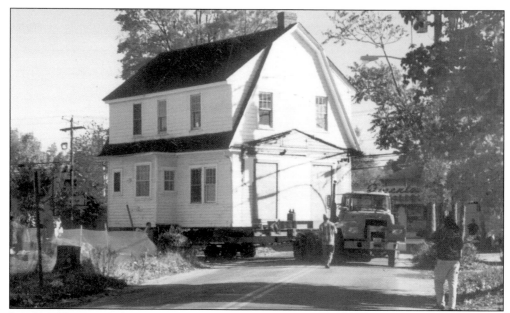

In 1904, Harry C. Bryant erected a barn, 22 feet by 30 feet, on his property on Smith Street, near the corner of Broadway. Later, the barn was moved to face Broadway and was converted into a house for John and Jennie Gillen. Jennie was a founding member of the Greenlawn-Centerport Historical Association and was for many years treasurer of the school district. In 1997, when the Greenlawn Post Office acquired the property for its new building, the house was moved once again—from Broadway, west along Smith Street to a new site at 41A. Evidence of the building's barn origin can be seen on the gable end of the house.

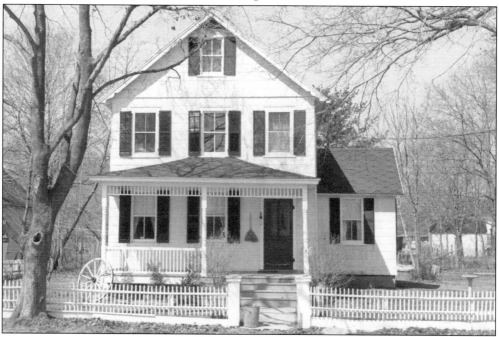

This house was built by Samuel Ballton in 1894 for William Hudson Jr, a blacksmith whose shop was adjacent to his home. The house still stands, now at 3 Smith Street.

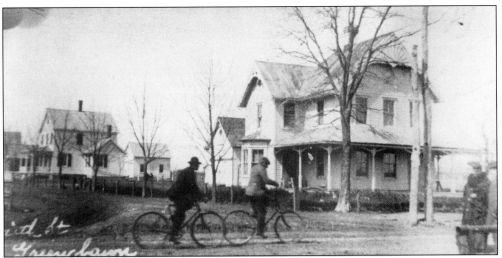

Samuel Ballton also built this house, c. 1894, for the Howarth family, the first owners of the general store. The house, as shown in this early view, faces Broadway near the corner of Smith Street. In the 1930s, it was moved to face Smith Street on the east side of the Hudson house, which is seen in the background. In 1997, the house was moved a second time to a plot on the west side of the Hudson house to make room for the new post office.

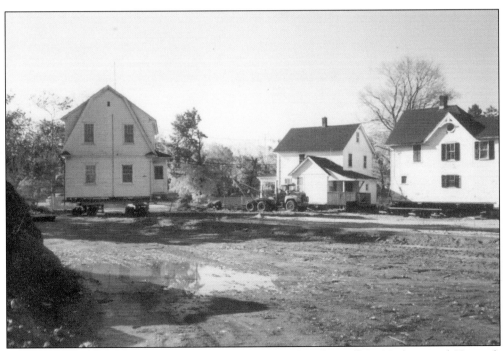

This October 1997 photograph shows, from left to right, the Gillen, Hudson, and Howarth houses in the process of being relocated along Smith Street.

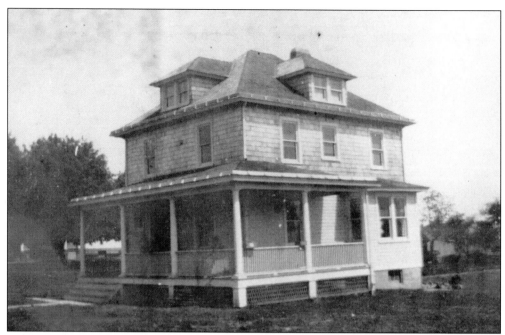

Leroy Tilden (1889–1975) married Daisy Gardiner in 1912 and built their home at 355 Greenlawn Road on land that was part of the original Israel Tilden homestead. He used a house plan ordered from the Sears catalog. Leroy farmed his family land, trucked produce to New York City, and seasonally operated a popular farm stand next to his home.

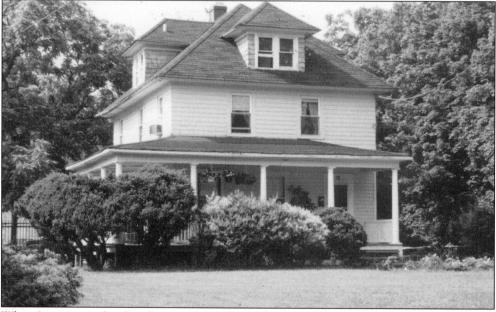

When Leroy's twin brother, Raymond (1889–1985), married two years later, he used the same plans, made some small changes, and built a home for his bride around the corner at 61 Smith Street. His land was also part of the original Tilden farm tract. Raymond did not farm for a living, but worked for the Town of Huntington. This photograph shows the Raymond Tilden home today.

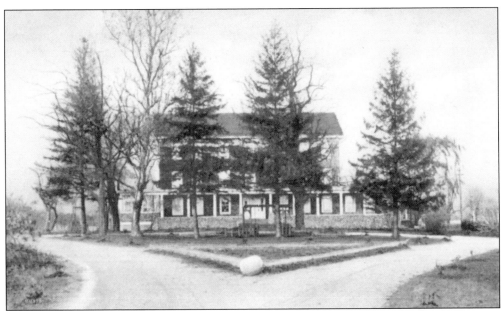

This house, located on the old Baylis homestead, was built on the site of the c. 1858 dwelling of Richard M. Baylis, the son of John Scudder Baylis and the brother of Orlando. The foundation, the floor joists, and some framing from the original dwelling were probably incorporated into the present structure, which was built for J. Putnam Cobb c. 1910. At the time of the Cobb ownership, the property extended to Greenlawn Road and contained seven outbuildings. Later, a fire destroyed some of the third floor, and the roofline was altered during rebuilding.

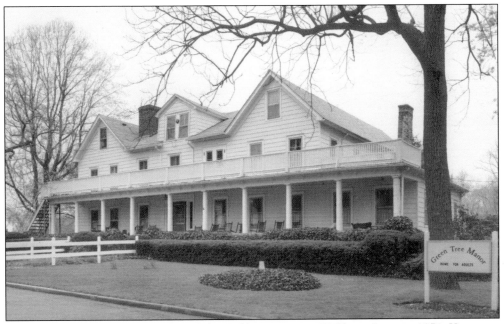

The Martin DeRiso family purchased the Cobb property at 17 Cherry Lane in 1971. Known as Green Tree Manor, it serves as an adult home. This photograph was taken in 1989.

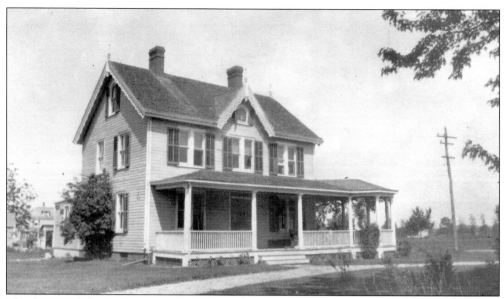

The home of Samuel Smith, built in 1887, featured Carpenter Gothic–style elements in its ornamentation. Samuel was the son of Charles D. Smith. He married Zipporah Smith, a daughter of George William Smith, who gave the couple the land for their home. Their daughter, Angeline, was the grandmother of Russell Brush, a founder of the Greenlawn-Centerport Historical Association. Samuel worked most of his life on his father's farm. This photograph was taken c. 1900.

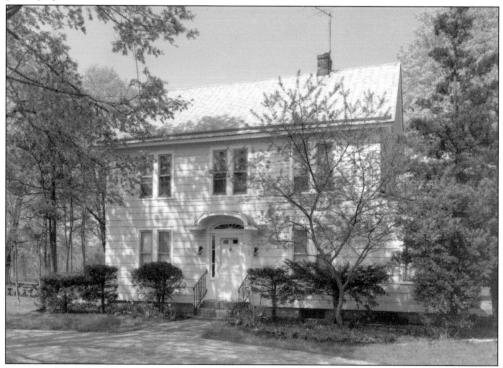

The Samuel Smith house still stands on the corner of Cuba Hill Road and Central Street. Its roofline was remodeled after a fire.

In the 1920s, Samuel Smith remarried and moved to a new house that he built farther east on Central Street. His second wife, Mrs. Champlin, a widow, was the mother of Helen Champlin Smith and Eva Champlin Gates. This view of the house, which still stands, was taken in 1989.

For several years, Eva Champlin Gates, the widow of Leroy Gates, lived with her sister Helen Champlin Smith in this house, which was adjacent to the home of their mother and step-father, Samuel Smith.

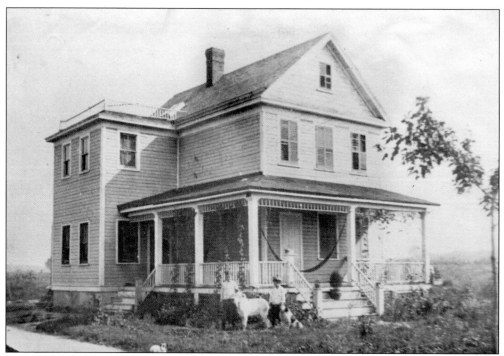

Among the first houses built on Boulevard Avenue, *c.* 1907, were these two owned by Adam Schaller. Adam and his brother Jake were both active in the Greenlawn Fire Company. In 1910, the new firehouse was erected west of Schaller's houses. Later, both houses were demolished to make room for the company's expansion.

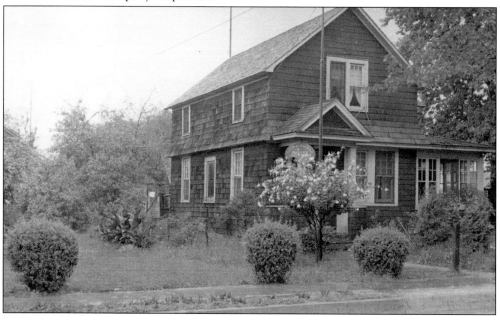

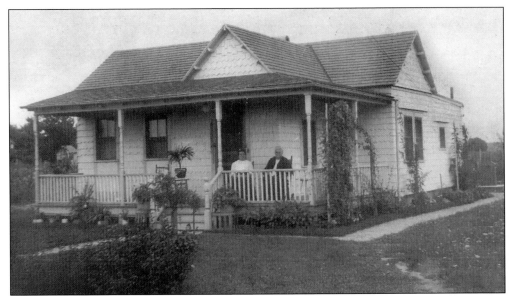

Known as the Cherry Cottage, this dwelling once stood on Smith Street, where a parking lot is today. Sometime between 1906 and 1910, Leroy Tilden, with his horse and wagon, moved the house to its present location at 34 Boulevard Avenue. The lady seated on the right is Annie Rae, the grandmother of Lloyd Rae.

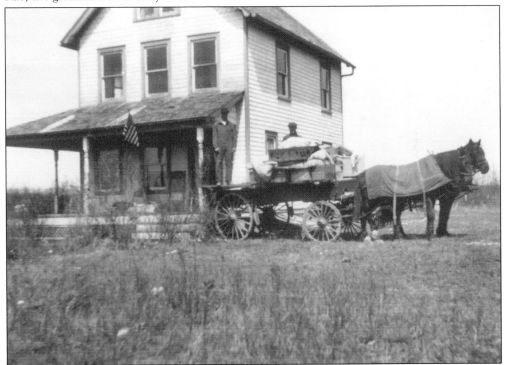

In April 1920, Charles Tilden, the older brother of twins Leroy and Raymond, moved his family by horse and wagon to this house, which still stands at 49 Fenwick Street. Although the house had been built much earlier, Fenwick Street had not yet been cut through to Broadway. In this moving-day photograph, Charles is behind the barrel and Raymond stands in back of the wagon.

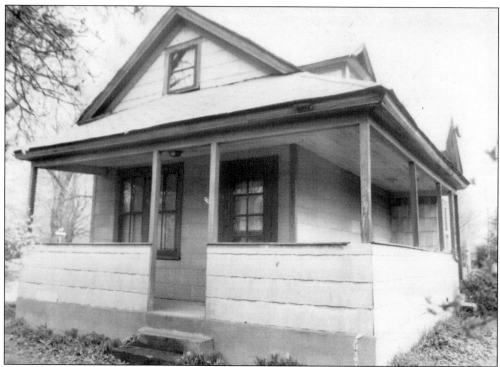

Samuel Ballton erected this building on Taylor Avenue between 1905 and 1910 for use as a store. Situated near the railroad tracks, it seemed to be a promising location. However, when the new railroad depot was built farther to the west, the location was no longer suitable for a business, and Ballton converted the building into a dwelling. Ballton's granddaughter, Berenice Easton, lives in the house today.

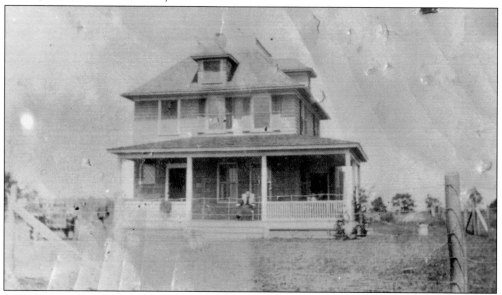

Built by Samuel Ballton in the 1890s, this house was the home of Charles Gardner and Marie Stoddard, who performed in vaudeville as the team of Gardner and Stoddard. The house still stands on the northeast corner of Taylor Avenue and Boulevard Extension.

Charles Gardner and Marie Stoddard were a popular husband-and-wife theatrical team. They performed in New York City and also went on the road here and abroad. In their routines, Gardner and Stoddard played musical instruments such as the cornet, the auto harp, and musical glasses. They also sang and presented entertaining skits.

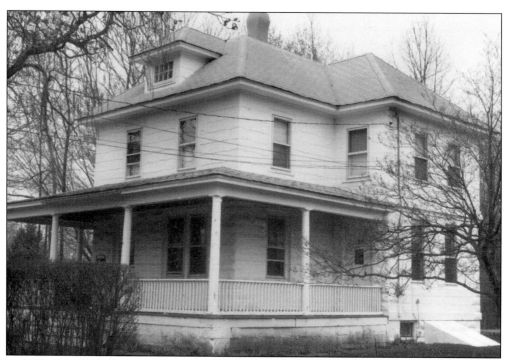

In 1911, Samuel Ballton and his wife, Rebecca, celebrated their 50th wedding anniversary in this house, which he had just built on Boulevard Extension. Most of their furniture had not even been moved in, but that proved fortuitous, as it allowed plenty of room for dancing.

This cinderblock and stucco dwelling at 67 Boulevard was the last house Samuel Ballton built. He died there in May 1917.

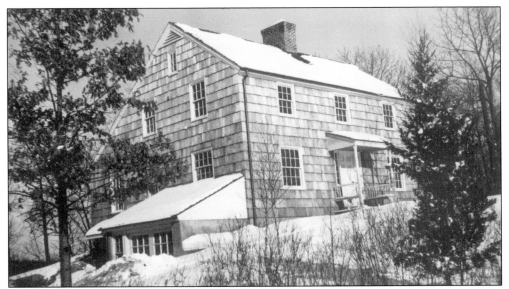

The Niemeyer home was constructed on a wooded bluff overlooking Centerport and Northport Harbors on land that was part of the original Cedarcroft tract. The Niemeyers purchased the property in 1937 and commissioned the New York architectural firm of Blodgett & Cramer to design a home with a traditional saltbox-style exterior and authentic Colonial detailing inside. The house was constructed by Northport builder Walter Tacke. The Niemeyers moved into their custom-designed home at the end of Jean Court shortly after their marriage in 1938.

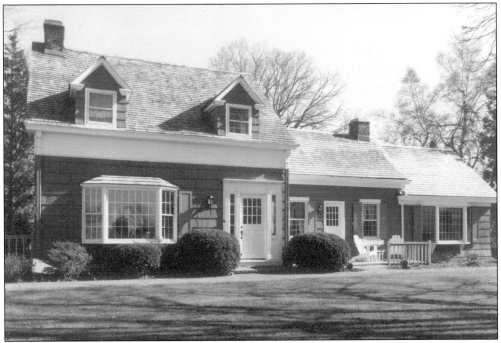

This c. 1756 farmhouse was originally located on Clay Pitts Road. It was moved to Ridley Court in the early 1950s. The kitchen wing on the right was added. The interior, beautifully restored by Mr. and Mrs. Warren White, retains the original fireplaces, moldings, doors, beams, and some glass.

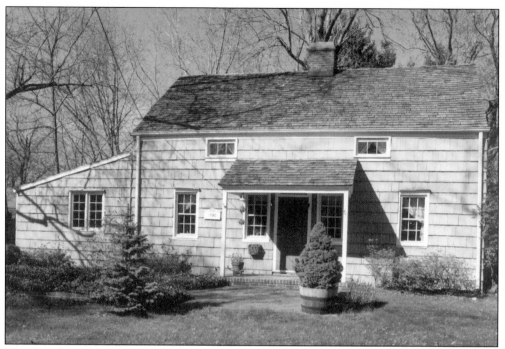

This Revolutionary War–era home of Morris Bartow, who fought under George Washington, was originally located on Laurel Hill Road. A secret cellar room, discovered when the house was moved, was reportedly used as a hideout for colonial soldiers. By 1945, the house was vacant and in disrepair. Russell A. Rodes purchased it and moved it to Arbutus Road. He called it the Little Cottage and carefully restored it, maintaining the integrity of the old dwelling. Before the house was moved, the massive central chimney was dismantled, hand-baked brick by brick, and reassembled at the new location. Inside, hand-hewn beams, wide floorboards with square nails, the original moldings, and other details remain. After the Rodes family moved, subsequent owners have continued to maintain this charming old home.

This interior view of the Little Cottage shows the period details in the entryway cupboard.

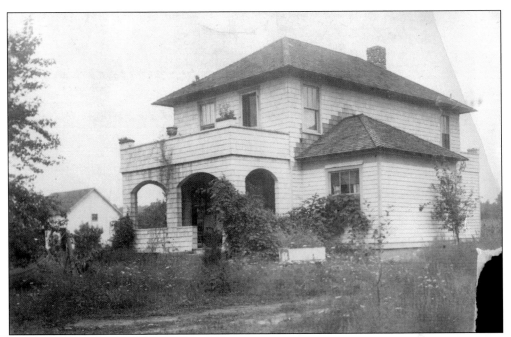

Charles A. Taylor (1864–1942) was a successful playwright and theatrical producer in the early 1900s. His wife, actress Laurette Taylor, often starred in his melodramas, performing dangerous stunts. Reportedly, Mr. Taylor was a farmer at heart. He purchased this property in Greenlawn, where he enjoyed a taste of bucolic life for a time with his wife and his children, Dwight and Marguerite.

In 1920, as work continued to keep him away from Greenlawn, Mr. Taylor put his vacation home up for sale with Northport real estate broker William B. Codling. Today, the Taylor house still stands at 5 Pine Place; its enclosed porch is the only visible exterior alteration.

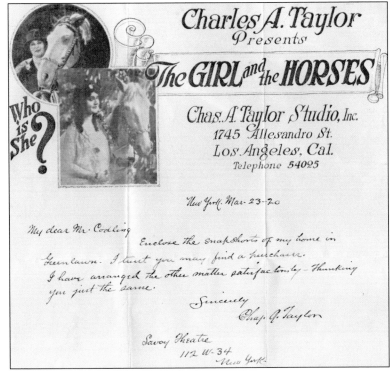

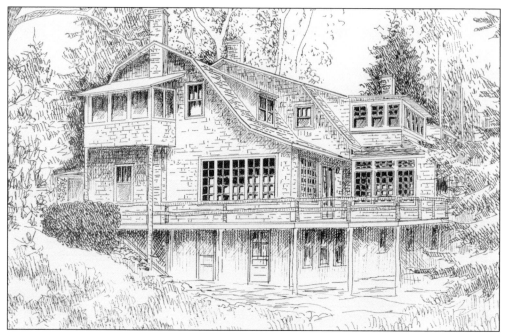

In 1905, Mr. Von Roosen, owner of the Standard Ink Company, bought this property, which was part of the Cedarcroft tract. He named his estate Laurel Lodge. Unlike most Long Island estates of the period, Laurel Lodge was designed in the rustic, Adirondack Camp style. In 1939, Dr. Edwin J. Grace and his wife, Gertrude Keating, bought Laurel Lodge from Von Roosen's widow. In 1994, when the property was offered for sale, the Daniel Gale Real Estate Agency prepared this sketch of the house. Although part of the land was subdivided for houses, the four Grace daughters conveyed 18 acres of the property to Huntington Town as a forever wild nature preserve in memory of their parents.

Situated on one of the highest points on Long Island, the view across the harbors and Long Island Sound to Connecticut is spectacular. This view looks from the porch of the main house.

In addition to the main house, the estate consisted of the guest cottage or studio shown here, a garage with chauffeur's and gardener's apartments, maintenance outbuildings, a tennis court, and a log cabin.

The log cabin was built deep in the woods, accessible only by footpaths. Von Roosen designed it to accommodate bachelor guests who liked to rough it.

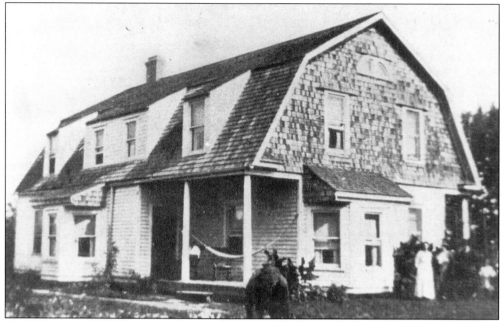

This gambrel-roof dwelling is believed to be the first house in the Cedarcroft development. It was constructed by E.S. McClay, who purchased 5 acres of property and built this two-family house in 1909. For many years, it was the home of Charles Rae and his wife, Annie Brush. After they died, their daughter Mazie Rae continued to live there. The house still stands at 14 Broadway with only minor exterior alterations.

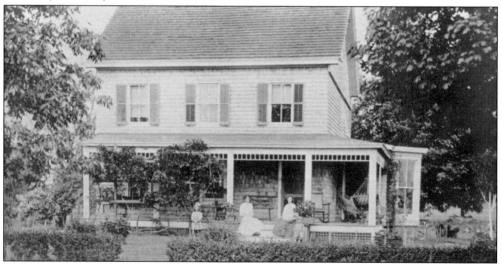

The George Rae Homestead at 26 Broadway was built in 1880. It is one of the oldest structures surviving on Broadway. The house was built by John Robertson and Martha Kissam on property Martha inherited from her father, Charles Kissam. It was later purchased by George Rae, a son of Charles and Annie Brush Rae, who lived up the road. Posing on the steps of her home, c. 1909, are Estelle, George's wife; daughters Lorna and Dorothy; and sister-in-law Mazie Rae. In 1935, Dr. J. Clarence Bernstein and his wife, Julia, moved into the house. Except for the four years that Dr. Bernstein was on military duty during World War II, the building served as the home and office of this popular village doctor until he retired in 1983.

Three

THE SCHOOLS, CHURCHES, POST OFFICE, AND FIRE COMPANY

The records of Oldfields School District No. 6 date back to 1832. In those days, children attended a six-month school held in a local farmhouse. In 1872, a half acre of land on the Huntington-Greenlawn Road near Tilden Lane was purchased from Luther and Celia Brush and a one-room school building was erected. It was a 22- by 24-foot structure; the total cost was $1,095, including the desks. This image is the oldest known photograph of the one-room schoolhouse. It was taken in 1882 by Nelson Munger, whose father, Divine S. Munger, then owned the farm adjoining the school property.

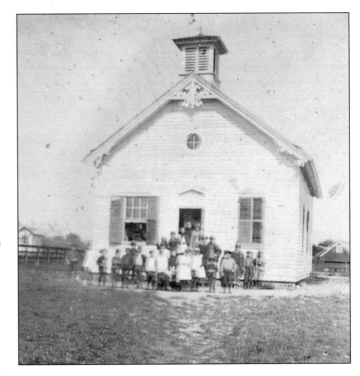

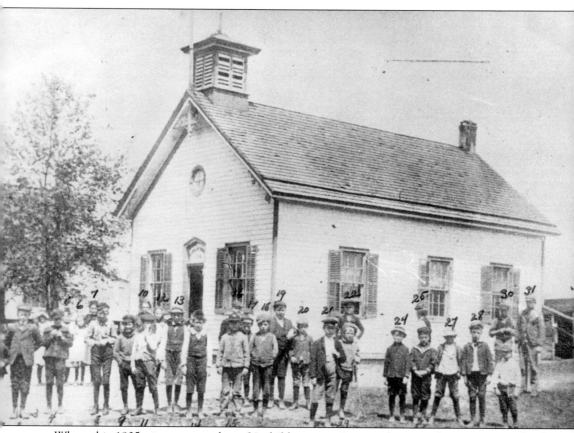

When this 1905 picture was taken, 31 children were in attendance at the one-room school. The numbers identify them as follows: Joe Driscoll (1), Clarence Gardiner (2), Rose Robertson (3), Melville Young (4), Ollie Wheeler (5), Emma Kennedy (6), Jessie Wightman (7), George Holsworth (8), Jake Schaller (9), Ruth Schlim (10), Harold Greene (11), Emma Wightman (12), Clifford Brush (13), Earle Smith (14), John Kaiser (15), Charlie Greene (16), Fred Holsworth (17), Percy Gardiner (18), George Lacker (19), Ferd Schaller (20), George Pole (21), Elliot Smith (22), Harry Schlim (23), Tootsie Hersh (24), Percy Smith (25), Otto Schmidt (26), Emmet Merrill (27), Albert BaRoss (28), Charlie Chapple (29), Rowland Chapple (30), and Tony Pole (31).

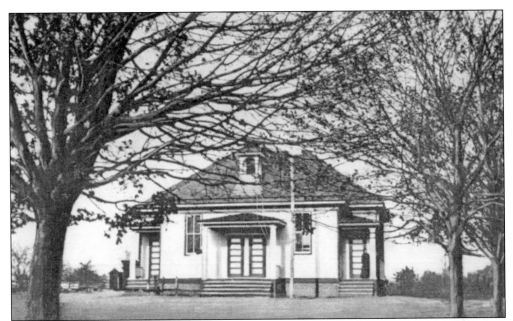

The outgrown one-room schoolhouse was replaced in 1908 by this two-room schoolhouse. There was one teacher for grades one through four and another for grades five through eight. The one-room schoolhouse was sold at auction, moved to the top of the hill between Greenlawn Road and Tilden Lane, and converted to a dwelling. It has been a residence since that time.

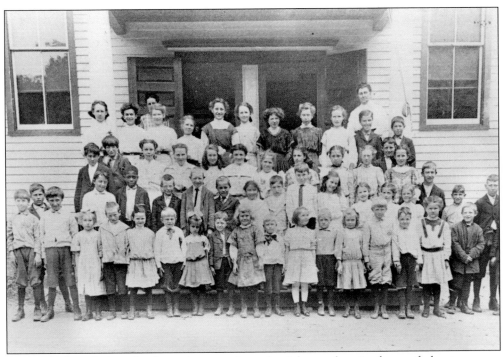

In 1909, the whole school, grades one through eight, gather in front of the two-room schoolhouse to have a picture taken. The teachers are Miss Conklin and Miss Kate Scott.

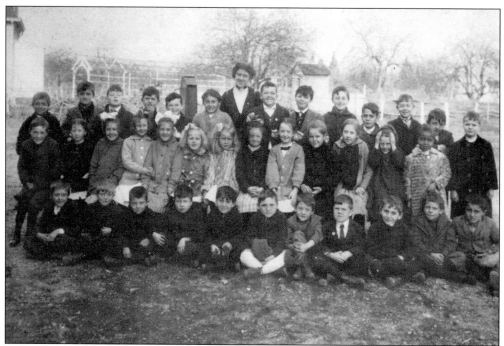

Pictured behind the two-room school in 1916, is the teacher, Miss Brooks, with her class. Students include Leo Steiner, Jonathan Hendrie, Harold Anderson, Selah Brush Jr., Irene Jenkins, Mildred Anderson, Bertha Schmidt, Edith Anderson, Stella Miskisky, Francis Miskisky, Alberta Gardiner, Alice Farmer, Helen Skidmore, Elsie Olson, Marie Ellis, Edwin Osborne, Edward Smith, Walter Andres, Jackie Burns, Walter Olson, and Clinton Wheeler.

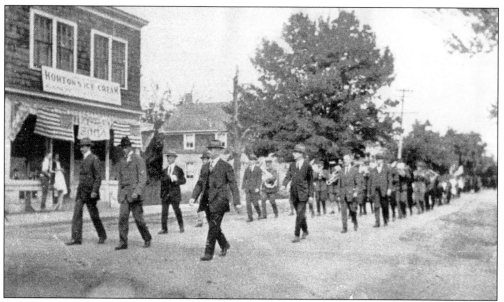

As the community continued to grow, additional classroom space was needed. In September 1924, a gala parade through the village preceded the festive cornerstone-laying ceremony for the new Greenlawn School building at 31 Broadway.

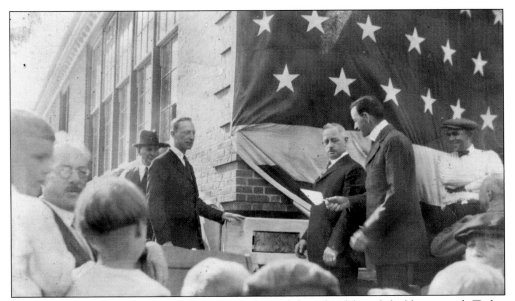

At the ceremony William Hendrie, the president of the school board, holds a trowel. To his right are Leo Steiner and Arthur Enggren, members of the school board. The man with the hat is Ed Smith, from whom the 5-acre school property was purchased.

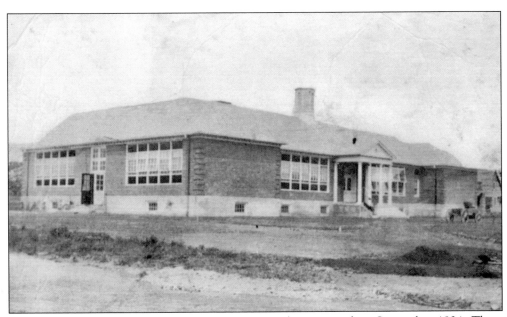

The new Greenlawn Grammar School at 31 Broadway opened in September 1924. There were five classrooms, an auditorium, a principal's office, and a library. It was expected that the community would continue to grow, so the architect, Norman Baker of Greenlawn, designed the building to allow for future expansion. The school cost $77,430, plus a six percent architect's fee.

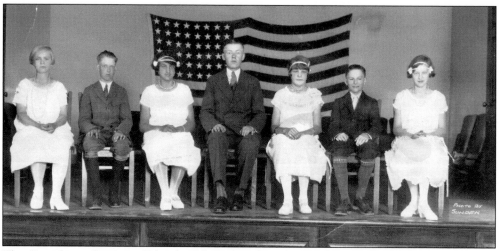

The Greenlawn Grammar School graduated its first class in 1925. Commencement exercises, complete with orchestral selections and speeches, were held in the auditorium of the new school building. Seen here, from left to right, are Adelaide Margaret Sundstrom; Lawrence Theron Gerard; Jennie Catherine Bivona; Walter Fotch, principal and teacher of seventh and eighth grades; Marcella Catherine Miskisky; Charles James Hughes, valedictorian; and Lillian Elizabeth Schubert, salutatorian.

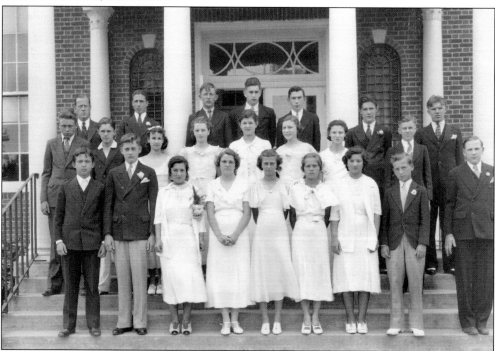

The eighth-grade graduating class of 1934, includes, from left to right, the following: (front row) Bernard Gleit, Robert Nass, Antoinette DeRiso, Lydia Wilson, Mary Sagan, Alfreda Modzelewski, Theresa DeRiso, Milton Bennet, and Walter Stockman; (middle row) Clarence Fairchild, Charles Hammond, Mary Parks, Gwen Sanders, Stella Moisa, Helen Noa, Muriel Foisset, and Ernest Hildebrand; (back row) Principal Fred Watkins, Martin DeRiso, Cornelius Rowehl, William Wyckoff, William Moran, Matthew Scott, and Alex Sweetman.

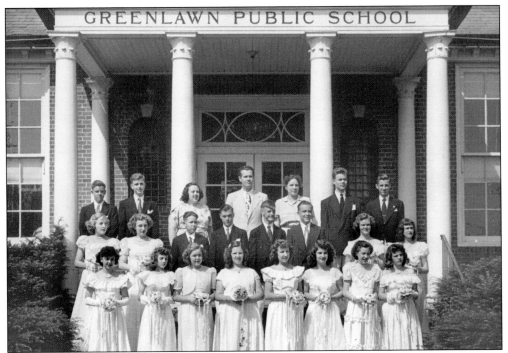

There were 20 graduates in the 1948 eighth-grade class: John Frank BaRoss, Nedra Carol Crowell, Marion Eisele, David Frambach, Lois Gould, Eleanor Johannessen, Robina ?, Norma May ?, Robert A. Linse, John Franklin Nelson, Alan Frederick Probeck, Roger Charles Rapp, John Devereux Reynolds, Suzanne M. Townsend Rodes, Myra Suzanne Schultz, Elizabeth Ann Shadbolt, Gladys Ruth Sittner, Mabelle Estelle Smith, Asta Edith Caroline Swenson, and William Wieck Jr. The principal was Thomas J. Lahey.

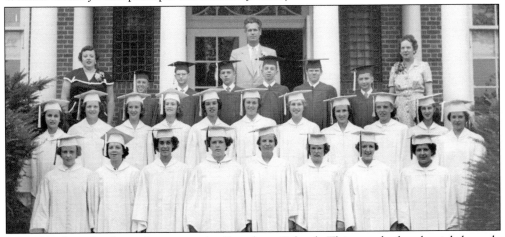

By 1952, the school was known as the Broadway School. This mostly female eighth-grade graduation class includes Margaret Babcock, Barbara Brush, Nancy Byers, Gail De Mascola, Donna Fenico, Dennis Freres, Conchetta Girardi, Barbara Gruebel, Margaret Guerin, Lamar Hill, Gordon Lindstadt, Edna Linse, Frances Martello, Susan Macfarlane, Lester Moulder, Philip Nixon, William Reynolds, Frances Romeo, Claudette Seyffert, Elizabeth Satterthwaite, Barbara Snyder, Ann Suydam, Irene Thomsen, Barbara Tienken, Caroline Van Cott, and William Walters. The principal was Thomas J. Lahey.

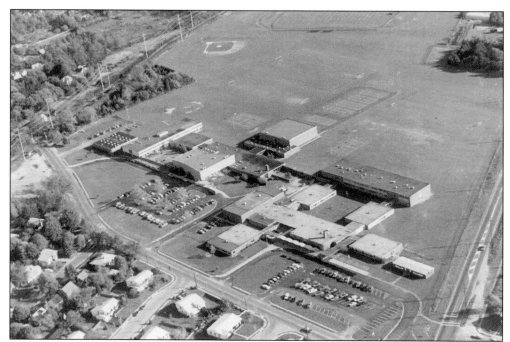

For years, the school district paid tuition for Greenlawn students to attend Huntington High School. In 1956, when this was no longer feasible, the Greenlawn School District and the neighboring Centerport School District consolidated. A high school was built on Taylor Avenue for the students of this new centralized district. A contest was held to name the district. The eighth-grade social studies class's winning entry was Harborfields. It combined the original names for Centerport (Little Cow Harbor) and Greenlawn (Oldfields). Harborfields High School opened in September 1959 and graduated its first class of 130 students in June 1960.

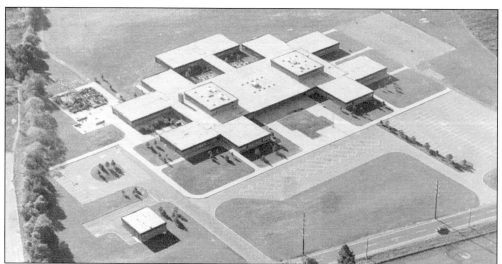

The Thomas J. Lahey School opened in November 1971 on Pulaski Road. This innovative building, designed by the architectural firm of Mignone, Coco, and Smith, had clusters of classrooms that could be combined for flexible programming. A state-of-the-art library media center was developed under the direction of librarian Margaret Hendrie Titus.

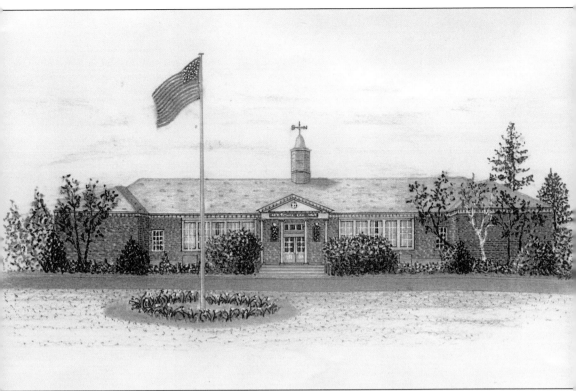

The Harborfields Public Library began service to the community in January 1971 from a 10-by 50-foot trailer parked at the Taylor Avenue School complex. Soon, the library moved to a portable classroom and then expanded into a wing of the school. In August 1976, the library relocated to the former Broadway School building, which had by then more than tripled in size. Over the years, the library's collections, services, and programs have provided information and recreation for community residents of all ages. The Greenlawn-Centerport Historical Association maintains its office and archives in the library building. This pen-and-ink drawing of the Harborfields Public Library was done by Bob Teufel in 1976.

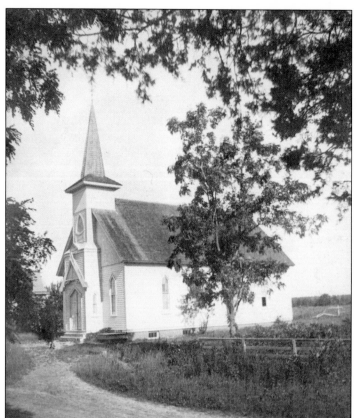

The First Presbyterian Church in Greenlawn was organized in 1872. A church building, constructed by George Brown, was completed in 1875 on farmland purchased from George William Smith. Unfortunately, the church burned down on Christmas 1877. It was immediately rebuilt and served the congregation until 1960, when the current building was completed. This 1890 view shows the picturesque church in its bucolic setting.

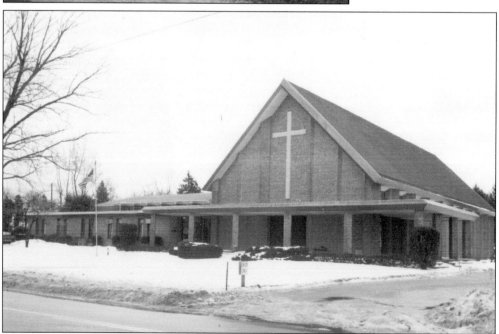

This is the First Presbyterian church today. Located on Pulaski Road east of Broadway, it was built on the site of the earlier church.

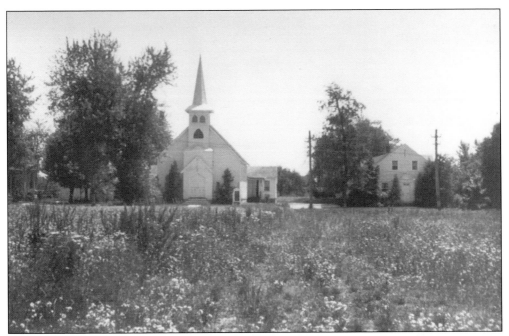

This view of the Greenlawn Presbyterian Church and its manse was taken *c.* 1940, when the church setting was still rural.

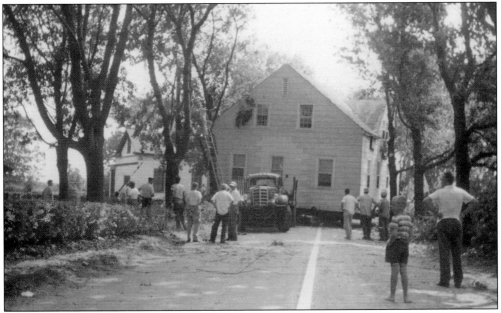

In the fall of 1957, the pastor's house was moved from the church grounds to 34 Fenwick Street. As the house was being moved along Taylor Avenue on a Friday afternoon, a tree just north of the railroad tracks blocked its path. The manse remained there over the weekend until permission could be obtained from the Greenlawn Beautification Committee to cut down the tree. When commuters drove up Taylor Avenue on Monday morning on their way to the train station, they found a house obstructing the road!

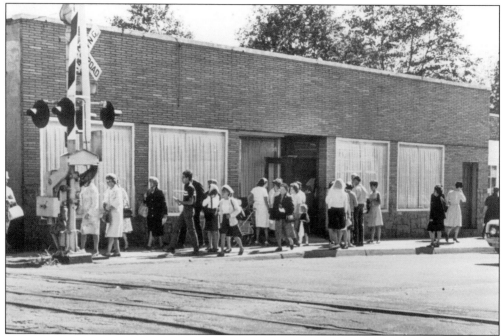

Through the years, visiting priests from neighboring parishes held local Masses. In 1926, an unsuccessful effort was made to establish a Catholic Church in Greenlawn on what is now Greenlawn Park acreage. Then in 1966, Fr. Joseph Keyes was assigned to establish a parish in Greenlawn to be known as St. Francis of Assisi. The brick building just south of the railroad tracks was transformed into a chapel for Masses, fundraisers, and other parish activities. Shown in this view is the storefront church at the time of the first Mass.

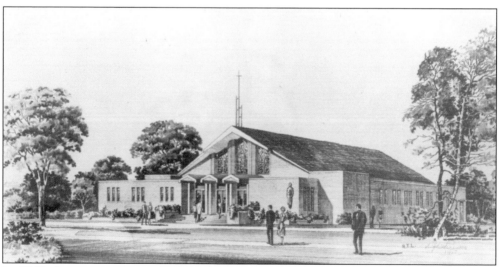

In 1969, the cornerstone was laid for the construction of the St. Francis church building on Clay Pitts Road, around the corner from the rectory at 29 Northgate. The church, shown in this rendering by architect Anthony De Pace was dedicated on June 13, 1971. The parish serves 1,750 families.

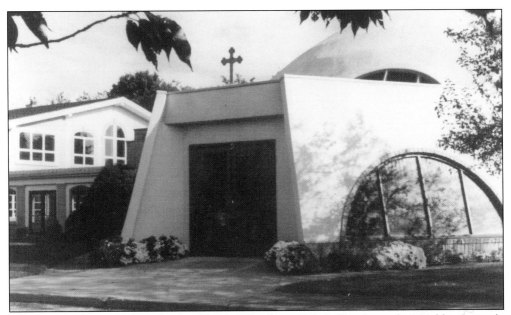

The St. Paraskevi Greek Orthodox Shrine Church on Pulaski Road was designed by Aristotle Taktikos. It features a self-supporting, thin-shell, reinforced-concrete dome 80 feet in diameter, circled at its base by crescent-shaped windows. The church was established in 1956, but services were first held in this building in July 1966. The church complex also includes a large community center, used for educational and social activities, and a Grotto Shrine.

This Grotto Shrine, which is unique in the Western Hemisphere, houses the relics of healing saints—St. Paraskevi and St. Panteleimon. It also contains holy waters from the Spring of St. Paraskevi in Therapia, Turkey, which are believed to have curative powers for eye diseases. Numerous miracle healings have been attributed to pilgrimages to the Greenlawn shrine, which is an exact replica of the original shrine in Therapia. The shrine was donated by John Yakovou.

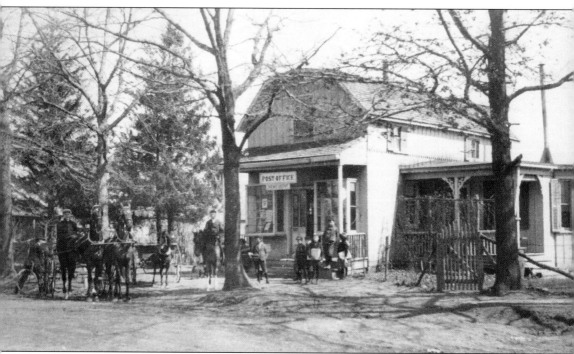

The first Greenlawn Post Office was located in the general store. The post office was later moved to this building on the east side of Broadway just north of the railroad tracks. The building also contained living quarters for the postmaster's family. James M. Hilton served as postmaster from 1898 to 1906, and his daughter Elizabeth was Greenlawn's postmaster from 1906 to 1919. This 1906 view shows villagers gathered around the post office awaiting the arrival of the mail train.

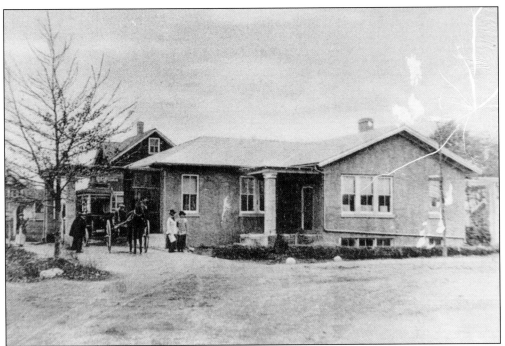

In 1911, a new post office was erected on Boulevard. The attractive bungalow-style building with a porte cochere garnered a lot of attention, for it was the work of a woman architect and builder Fay Kellogg, who had a summer home in Greenlawn. It was also designed with a woman occupant in mind, as Elizabeth A. Hilton, the postmaster, was to live there.

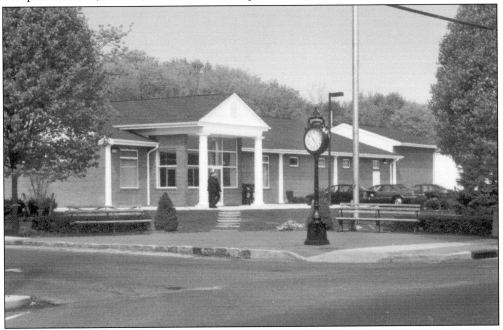

On April 24, 1998, a new, modern post office building on the northwest corner of Broadway and Smith Street was dedicated. It replaced the outgrown post office on Gates Street that had been in use since the 1950s. Anthony Fontana became Greenlawn's 18th official postmaster.

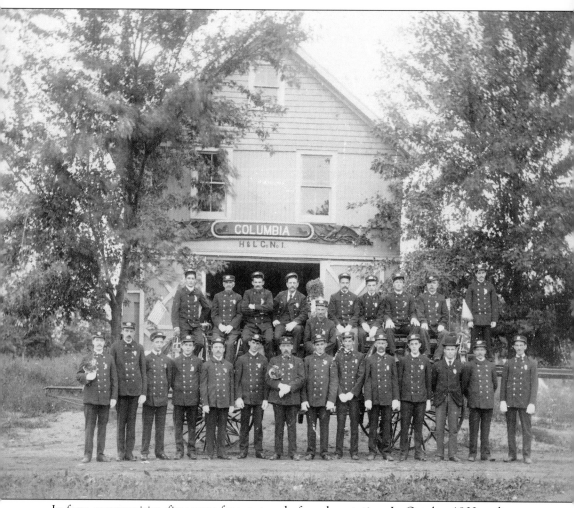

In farm communities, fires were frequent and often devastating. In October 1902, a disastrous fire at the Townsend farm led to the formation of the volunteer Columbia Hook and Ladder Company. At first, the hook and ladder truck was kept in a barn behind John Deans's store. Then, in 1905, a plot of land was purchased on Gaines Avenue. The old barn on the property was remodeled to become the headquarters of the Columbia Hook and Ladder Company. In this 1906 photograph, most of the charter members of the fire company pose in front of their new firehouse. Fire Chief John Deans is on the far left.

At this time, a number of vaudevillians summered in Greenlawn and presented programs in theaters in nearby communities. In 1908, the firemen issued bonds to fund a theater next to the firehouse. The theater was grand—72 feet long and 45 feet wide. It had electric lights, steam heat, and $2,000 worth of scenery donated by the actors' colony. The Columbia Opera Hall opened in December 1908. Performances by school, church, and community groups, as well as by the vaudevillians, filled the calender. Then, on Halloween Eve 1909, a fire that started in the firehouse quickly spread, engulfing the opera house and the nearby Columbia Hotel with its attached bowling alley. In the terrible conflagration that followed, all were destroyed.

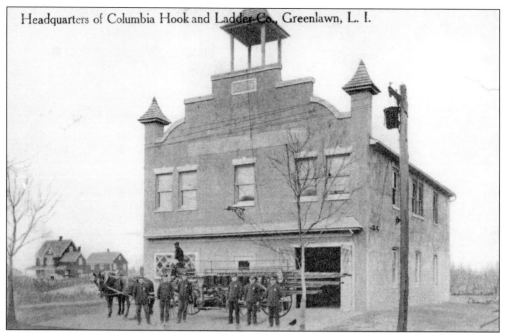

Headquarters of Columbia Hook and Ladder Co., Greenlawn, L. I.

The following year, a new firehouse was built on Boulevard Avenue. The first floor provided space for firefighting equipment. On the floor above, there was a large entertainment hall that included a stage. It served as a social center for Greenlawn. Here, movies were shown and theatricals were performed for the whole community to enjoy. In this photograph, firemen stand proudly beside their horse-drawn pumper in front of the new firehouse.

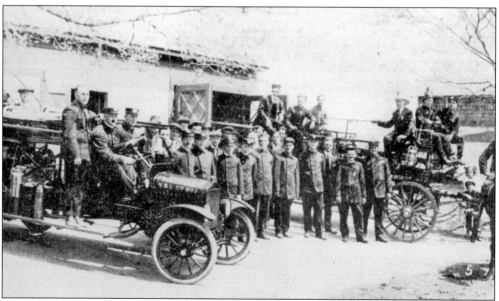

Shown side-by-side in this c. 1920 view are the old horse-drawn hook and ladder and the new motorized Model T chemical truck. The chemical truck improved firefighting by discharging fluid under high pressure.

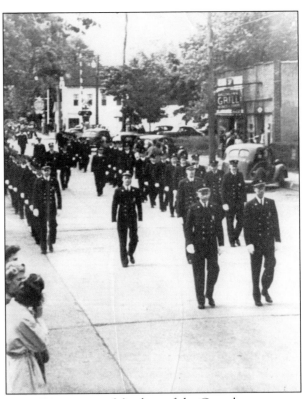

Members of the Greenlawn
Fire Department and the Ladies
Auxiliary march north along
Broadway during the 1947
Memorial Day parade.

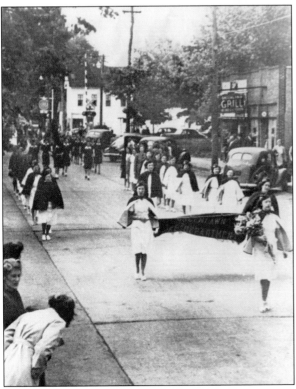

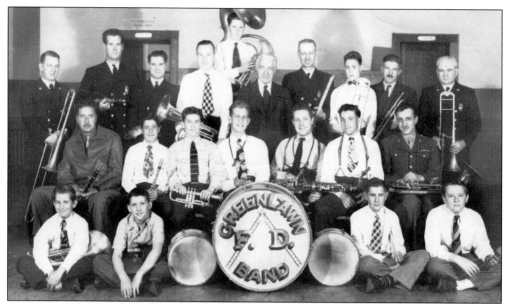

The Greenlawn Fire Department Band was formed in 1928 under the direction of James Sullivan Latham; for about 20 years, they performed in parades, graduations, and community events. Shown in 1945, band members include, from left to right, the following: (front row) Tom BaRoss, Kenny Brown, Richard Alber, and Charles Felmuth; (middle row) Carl Kretzer, Rudy DeRiso, Wade Lange Jr., Bob BaRoss, Pete Keda, Frank DeRiso, and Charles Bivona; (back row) Wade Lange, Thomas Lahey, Edward Freres, Robert Mack, Al BaRoss, Joseph Psota (director), Louis BaRoss, Richard Frew, Joseph Psota Jr., and Earle Smith.

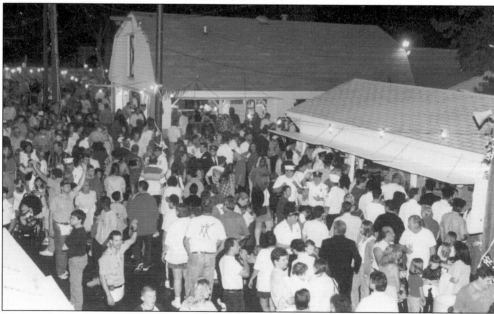

In Greenlawn, the annual Fireman's Fair held on Labor Day weekend marks the end of summer. As depicted, this festive time of games, prizes, rides, and refreshments attracts huge crowds. The Greenlawn Fireman's Fair dates back to 1906, making it the oldest, continuously run Fireman's Fair in New York State.

Four

TRADE AND INDUSTRY

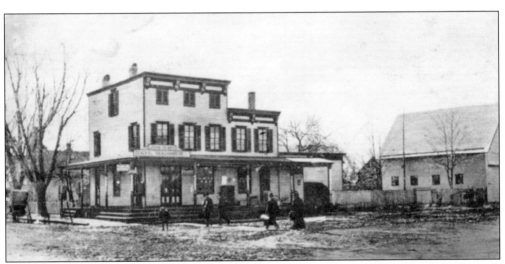

When the Long Island Rail Road was extended through Greenlawn in 1868, Hezekiah Howarth opened a general store opposite the depot. Later, Henry I. Smith and then W.J. Goodale, who installed Greenlawn's first telephone, ran the business. This photograph shows the store soon after it was acquired by John Deans in 1899. Deans was very enterprising; he added new merchandise and enlarged the building. Still standing at 83 Broadway, the old building, with its third-floor living quarters removed, is now the Greenlawn Hardware Store.

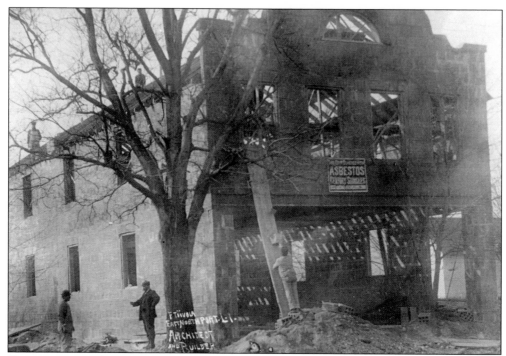

Having prospered and outgrown the old general store, Deans hired architect and builder Fred Tiivola of East Northport to design a large, modern two-story building with the latest amenities. Constructed of thick terra-cotta building blocks, the building was virtually fireproof. His merchandise, made accessible by floor-to-ceiling traveling ladders, included a great variety of groceries, drugs, animal feed, clothing, notions, hardware, and housewares. He even had a circulating library. The building, completed in 1910, still stands at the southwest corner of Broadway and Smith Street with the words "The Greenlawn Store" embossed below the fan-shaped window.

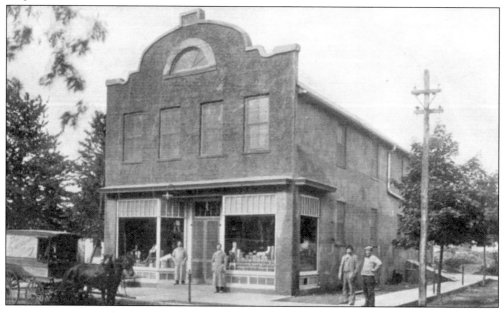

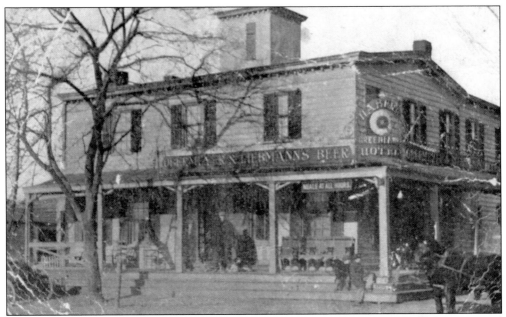

Before 1870, in anticipation of visitors arriving by railroad, the Greenlawn Hotel was erected across the street from the depot. Over the years, the hotel had various owners and names, including Ritter's, Merrill House, Haber's Hotel, and Ward's Country Inn. By 1920, the hotel was no longer profitable. With Prohibition, however, the building continued to be used as a speakeasy and gambling hall. Eventually, it fell into disrepair and was torn down. In 1956, the Old Field's Inn, operated by Frank Le Pera, opened in a new building constructed on the site.

The Columbia Hotel, owned by Otto Schmidt, opened on July 3, 1907. It had an attached four-lane bowling alley and stood at the corner of Gaines and Railroad Streets. In the disastrous Halloween Eve fire of 1909, the hotel and bowling alley burned to the ground. Otto Schmidt, however, soon rebuilt his hotel (but not the bowling alley). In later years, it was known as the Greenlawn Inn and housed Chirillo's Restaurant. The building was again destroyed by fire in 1994.

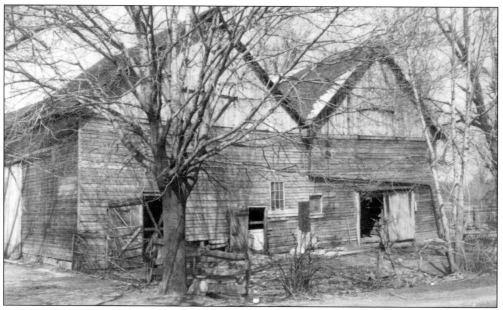

Among Alexander Gardiner's many enterprises was an ice business. Around 1900, he built this large icehouse on Lake Road. Blocks of ice were cut from nearby Gardiner's Lake and carried into the icehouse by chain conveyors. The blocks were stored until the summer demand when they were sold to ice companies in Northport and Huntington. This operation was discontinued in 1911, when ice companies started using electricity to manufacture what was called "artificial" ice. Later, the icehouse was used as a barn. The building was demolished in the early 1990s, after it had been abandoned for many years and had fallen into disrepair.

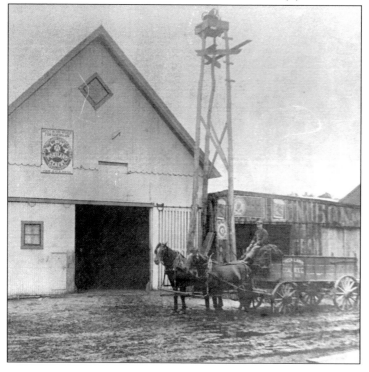

John Deans also had an icehouse and an adjoining coal shed behind his general store. In this 1904 view, Bert Deans is driving the Coal & Ice Company wagon, which went from house to house delivering blocks of ice for home iceboxes in summer and coal for stoves in winter. The horses, Dick and Harry, also pulled the Columbia Fire Company's hook and ladder truck that was kept in the barn at this time. The bell, suspended in the three-legged tower, served as the first fire alarm.

Greenlawn's village blacksmith was Bill Hudson, who is shown with some of his customers in front of his shop in 1911. The smithy was located on the north side of Smith Street between Broadway and Gaines Avenue. It was adjacent to his home, which still stands at No. 3.

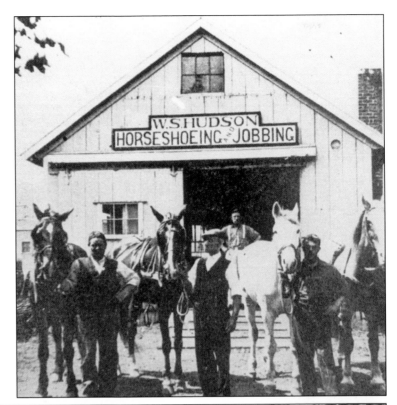

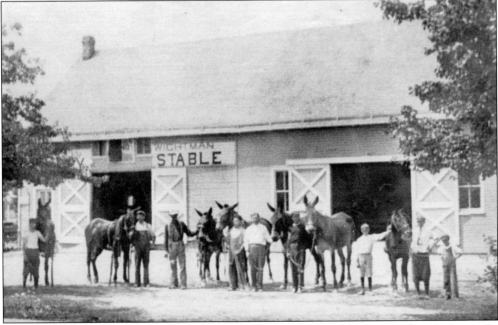

The Livery Exchange was established c. 1900 by Edward Gates and his son-in-law, Ira Lewis. By 1915, when this photograph was taken, the livery had been enlarged and was owned by Mark Wightman and Edward Smith. The stable was located on the north side of Boulevard between Broadway and the present firehouse. It was torn down in 1917.

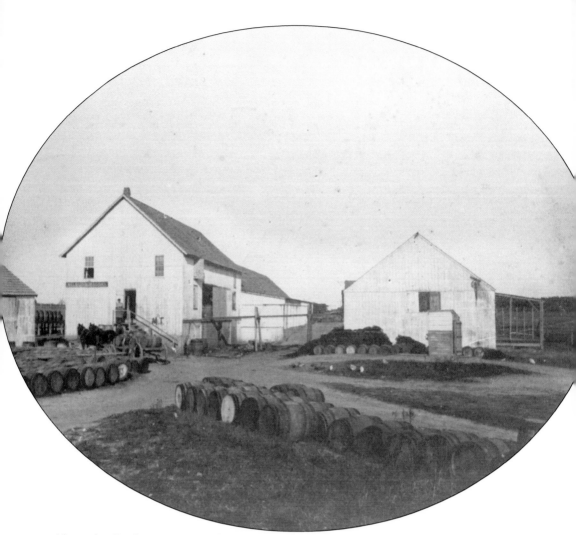

Alexander Gardiner was one of the first area farmers to recognize the potential of pickles as a lucrative cash crop. On his 600-acre Greenlawn farm, Gardiner planted fields of pickles (cucumbers less than 4 inches long) and cabbage and encouraged local farmers to follow his lead. In the early 1880s, he erected several buildings adjacent to the railroad tracks that ran through his land. He leased the space to processors so that they could be near both their supply and easy transportation to New York City markets. After processing, the pickles were shipped to New York City in heavy wooden barrels. In the 1920s, a disease called "white pickle" afflicted the Long Island crop. No remedy could be found, and pickle growing ended in Greenlawn. However, for his efforts in promoting the local pickle industry through the years, Alexander Gardiner became known as "Greenlawn's Pickle Pioneer." Here, he is shown in the doorway of his pickle works near Lake Road.

Samuel Ballton was born a slave on a plantation in Westmoreland, Virginia. He escaped during the Civil War and, after many terrifying adventures, arrived in Greenlawn in 1873. For a time, he sharecropped on the Alexander Gardiner farm and was a highly successful grower of pickles and cabbage. In one season, he raised 1,500,000 pickles and earned the title "Greenlawn Pickle King."

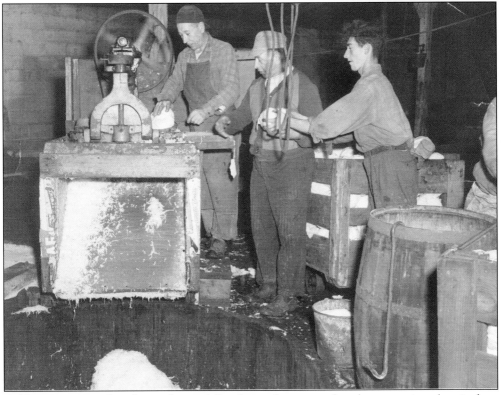

Cabbage was cut in late September and October and was carted to the processing plant in farm wagons fitted with special cabbage racks. At the plant, the cabbage was cored, sliced, and put into large wooden vats, where it was salted, brined, and trampled by workers into sauerkraut. Here, Hymie Golden, the son of Abraham Golden who established the family business c. 1885, helps core the cabbage. Golden's Pickle Works was located on the south side of the railroad tracks, west of Broadway, and had a huge green pickle on the roof. The plant produced an assortment of dill, sour, and garlic pickles, pickled tomatoes, peppers, and sauerkraut using Abraham's own recipes. After the pickle blight, the plant continued to make sauerkraut into the 1940s.

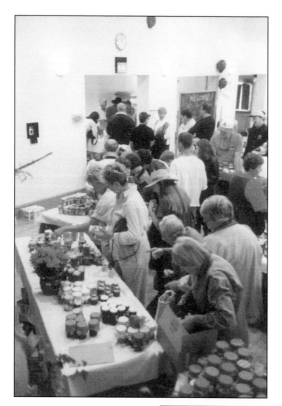

Each fall since 1977, the popular Greenlawn Pickle Festival has served to commemorate Greenlawn's pickle industry. Throughout the summer, members of the Greenlawn-Centerport Historical Association prepare pickles, relishes, jams, and jellies using old family recipes. At the festival, visitors can taste and purchase these items and learn about the pickle industry. Shown is a scene from the 1998 Pickle Festival.

This is a favorite Greenlawn pickle recipe.

Bread & Butter Pickles

4 Quarts Medium Unwaxed Cucumbers, not peeled, sliced thin. (Measure after slicing.)
6 Medium Onions, sliced
2 Green Peppers, seeded and chopped
3 Cloves Garlic
1/3 Cup Kosher salt
Cracked Ice
5 Cups Sugar
1 1/2 teaspoon each Turmeric & Celery Seed
2 Tablespoon Mustard Seed
3 Cups Cider Vinegar
Combine cucumbers, onions, peppers and whole garlic cloves. Add salt. Cover with cracked ice and mix thoroughly. Let stand 3 hours. Drain well. Combine remaining ingredients and heat to a boil. Add the drained vegetables, heat just to a boil. Place in sterile, hot Jars. Process 10 minutes. Makes 8 Pints.

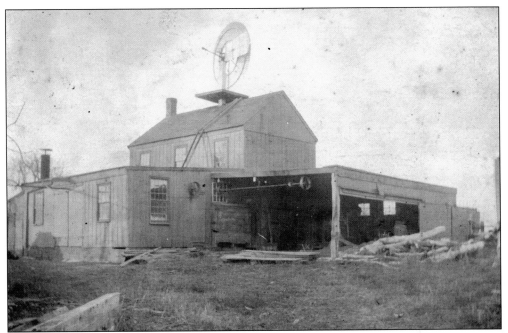

This 1905 photograph shows Alexander Gardiner's c. 1860 sawmill at the southeast corner of Lake Road and Park Avenue. The mill provided lumber for local ship builders and, in return, Gardiner received an interest in the shipping businesses. The building was later used as a residence until it was destroyed by fire.

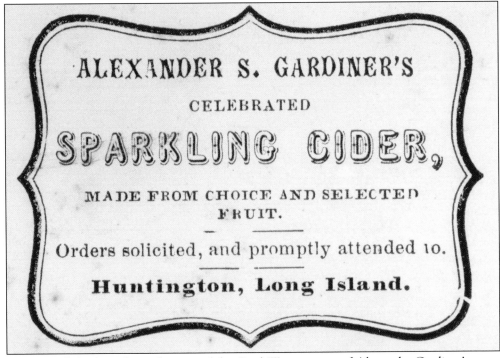

ALEXANDER S. GARDINER'S

CELEBRATED

SPARKLING CIDER,

MADE FROM CHOICE AND SELECTED FRUIT.

Orders solicited, and promptly attended to.

Huntington, Long Island.

A cider mill, built in the early years of the Civil War, was one of Alexander Gardiner's many business enterprises. This business card promotes the mill's sparking cider.

This early building is shown in the 1880 Lange painting of Greenlawn Village. Over the years, it housed many different businesses, including Robert Gurney's Apothecary Shop, the Greenlawn Post Office, the Bivona Barber Shop, a shoemaker shop, and a beauty parlor.

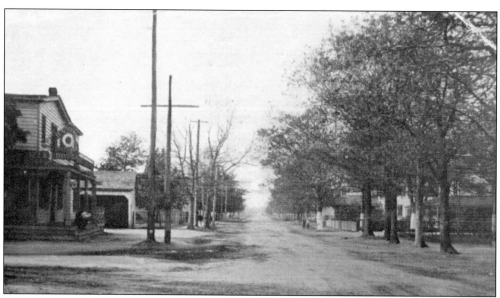

In 1917, Broadway was just a country road.

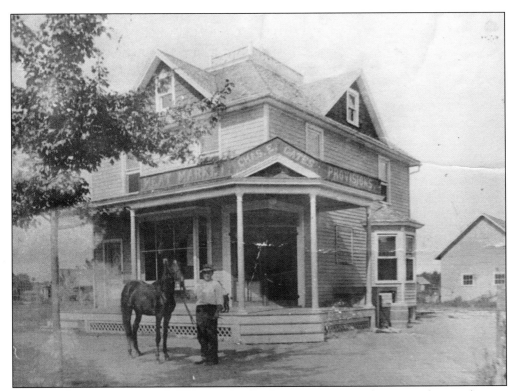

In 1907, the Charles E. Gates family moved to their new home and meat market on the east side of Broadway, north of Boulevard. In this 1910 view, Mr. Gates stands beside the horse that pulled his delivery wagon. In later years, the building was used as a shoemaker's shop. After it burned down in 1973, it was replaced by a row of stores.

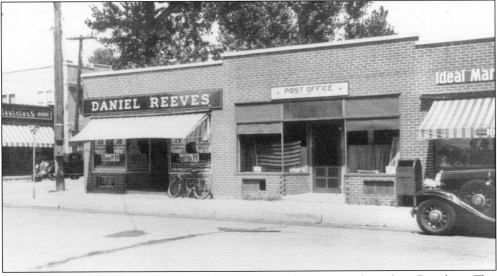

Before Greenlawn had a supermarket, there were several grocery markets along Broadway. This 1942 view of the corner of Broadway and Boulevard shows the Daniel Reeves Grocery Store, the Ideal Market, and Roulston's. Later, there was Clouston's, located in the brick building on Broadway, just south of the railroad tracks.

Myersberg's Drug Store was on the southeast corner of Broadway and Lawrence Street. In writing about his school days in the late 1920s, James BaRoss recalls the special occasions when he was allowed to buy lunch there. A sandwich cost 5¢.

Generations of boys and men had their hair trimmed at the Bivona Barber Shop, located at first in the building on the east side of Broadway, just north of the tracks. In 1924, John Bivona built a new shop and residence for his family across Broadway at No. 69. In the late 1950s, the barbershop was moved next-door to No. 67, and the Bivona family moved to a new home on Taylor Avenue. When John retired, his son Vincent took over the business.

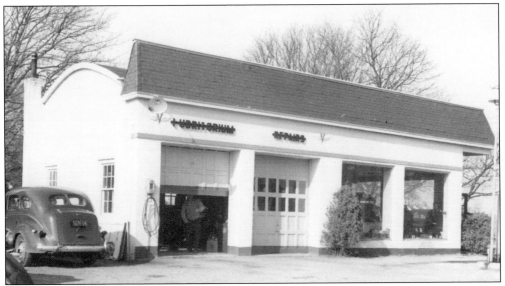

In 1938, Doug Gates sold his Tydol station, located on Broadway south of the tracks, and built a new garage and service station at the northwest corner of Broadway and Pulaski Road. He purchased the house on Broadway adjacent to the station for his family. It had been the summer home of vaudeville star Nicholas Long. This view shows the station in 1948.

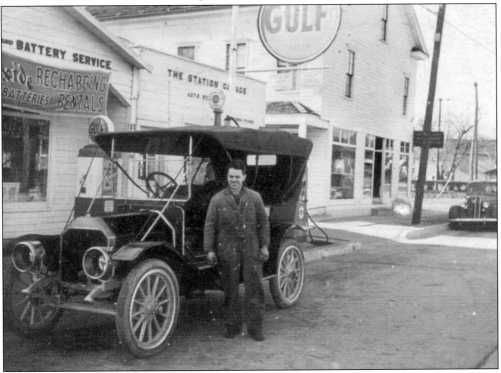

Albert Miltner in front of the service station, c. 1940, which he and his brother-in-law, Everett Tilden, had purchased from Doug Gates. Later, Miltner moved his business to the northeast corner of Broadway and Fenwick Street, where Miltner's Garage continues in operation today as a family business.

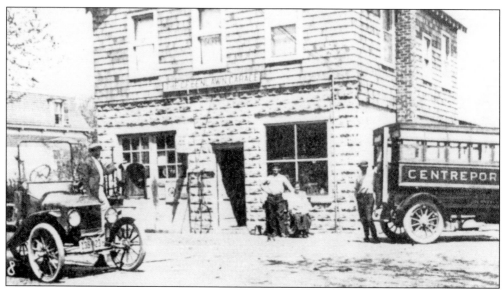

Emil Nass owned the Greenlawn Garage on the northeast corner of Broadway and Grafton Street when this photograph was taken in 1920. It was later owned by Henry Rueger. Steve Miskisky began working for Mr. Rueger when he was 16 years old and eventually took over the business. He operated the station until his retirement in 1988 at age 75.

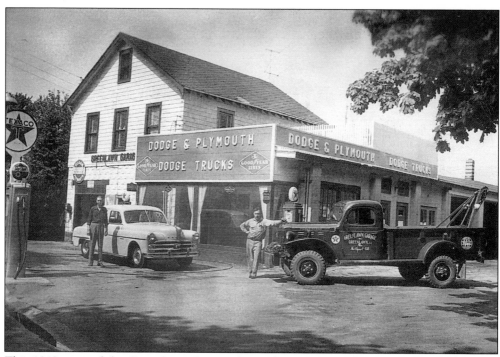

This 1948 view of the Greenlawn Garage shows the extension that had been added to the original building. By that time, the business included a Dodge and Plymouth dealership. The Miskisky family lived above the garage in a spacious apartment with a roof terrace. In the early 1960s, the family relocated, the garage was renovated, and the gas pumps were moved back from the sidewalk.

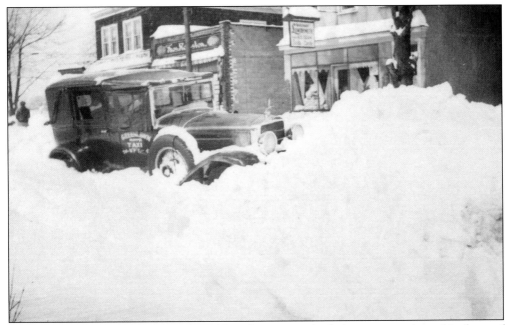

On February 21, 1934, this Greenlawn Taxi Company vehicle became snowbound in front of the taxi office on Boulevard. The company was then owned by a Mr. Sullivan.

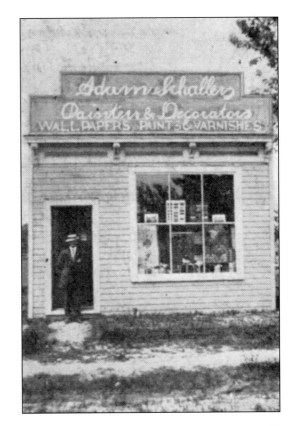

Adam Schaller's Painters and Decorators Shop opened on the Boulevard in 1908. In addition to selling paints, wallpapers, and varnishes, Mr. Schaller was a master painter. Among his large commissions was the George McKesson Brown estate (Coindre Hall). Mr. Schaller also had a hothouse and florist business.

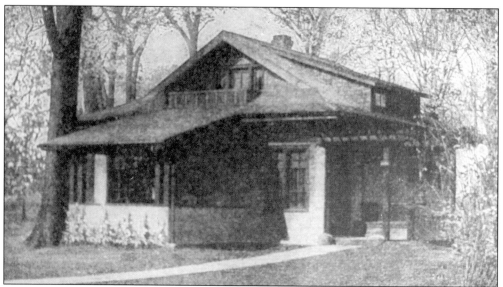

Christine McGaffey Frederick (1883–1970) moved to Greenlawn in 1912. From her home on Cuba Hill Road, known as Applecroft, she conducted studies on household management. Mrs. Frederick pioneered the application of time and motion studies to household chores. She analyzed every household task from washing the dishes to bathing the baby. Through careful experimentation, she determined the most efficient way the housewife could accomplish each chore. Mrs. Frederick lectured and published widely. She also held classes at Applecroft, teaching women how to organize their homes and free themselves of unnecessary labor. The ideas developed at Applecroft were very popular and greatly influenced home design for the middle class. This influence can readily be seen in the popular catalog plans of the 1920s and 1930s. Many of these designs were built in Greenlawn and can be seen here today.

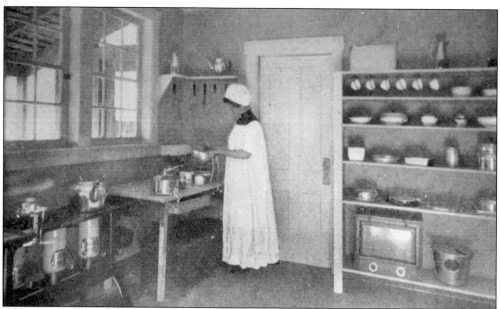

Christine Frederick is shown here in her efficiency experiment kitchen at Applecroft.

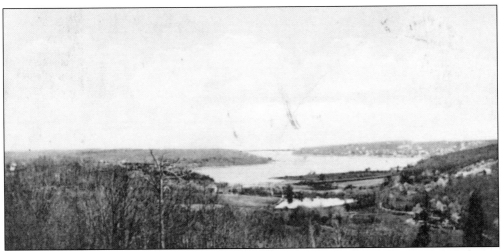

In 1904, the land on the east side of Broadway, running north of East Maple Road to the top of the hill, overlooking Centerport and Northport Harbors, was sold to a real estate corporation organized by Willard N. Baylis of Huntington. This land had been the north section of the Charles Kissam farm. The company named the area Cedarcroft because of the abundance of cedar trees on the site and made plans to subdivide the property into plots of 4 to 5 acres. Due to an insufficient water supply, the plan never materialized. However, some of the plots were sold, including land at 14 Broadway upon which E.S. McClay constructed his home in 1909.

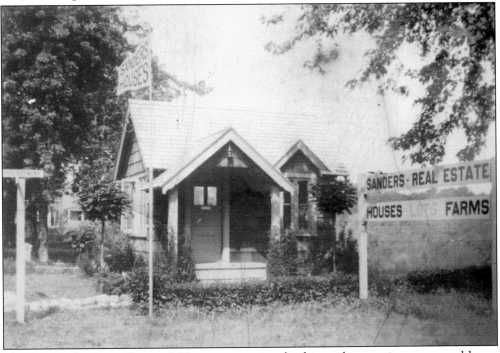

The Sanders brothers, Burt and Clarence, were involved in real estate, insurance, and home building. They operated their business from this building on the northwest corner of West Maple Road and Broadway. About 1950, J. Russell Vollmer Sr. used the building as the first office for his real estate and insurance agency. Mr. Vollmer's sons continue this insurance business today from their offices at 44 Broadway.

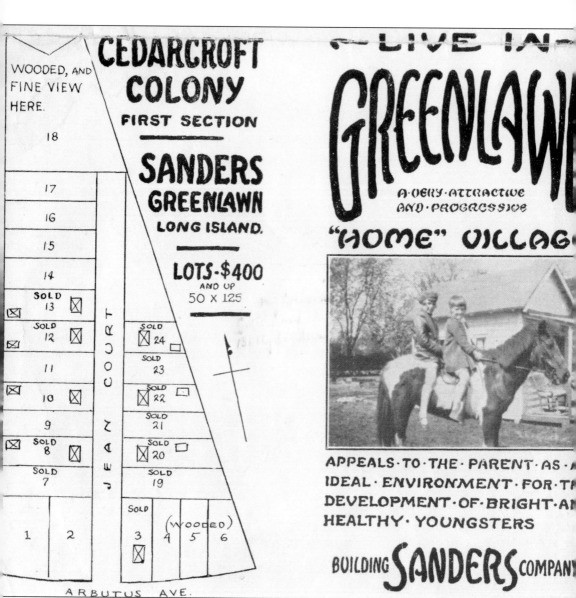

When Clarence and Burt Sanders entered the building business in the 1920s, they acquired some of the original Cedarcroft property on what is now Jean Court and Barbara Court. They envisioned there a development of homes for middle-class families. On Jean Court, the first section of the development, building plots could be purchased for $400. Their "Cedarcroft Colony" offered a choice of eight home models. Sanders's homes were typical of the catalog homes of the period in both design and construction.

 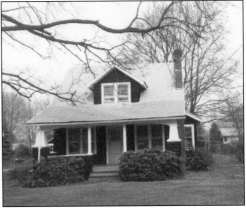

Although the Sanders brothers never succeeded in developing the area to the extent they had envisioned, they did build many homes on the Cedarcroft tract and spot-built homes on the west side of Broadway on Alvord Court, West Sanders, West Maple, and Gwen Court; this land had been the Sanders's family strawberry fields. Exteriors of many Sanders's homes remain intact today. In other homes, porches have been enclosed and dormers added. Yet these houses are recognizable as the models shown in the Cedarcroft Colony brochure of 1927.

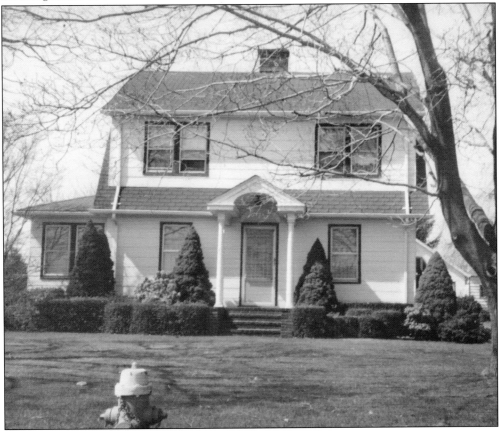

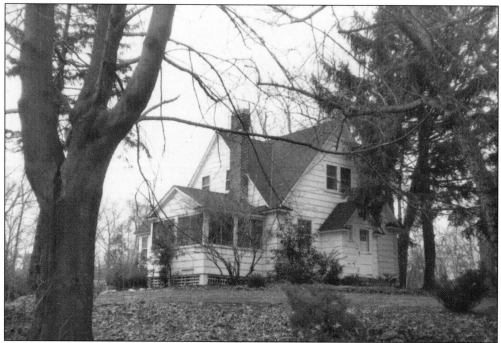

This photograph shows the comfortable two-story home with sweeping gabled entryway that Burt Sanders built in 1928 for his own use. It contained a screened porch, a sunroom, and numerous built-ins. An interesting feature is the four tree trunks in the basement used to support the dwelling.

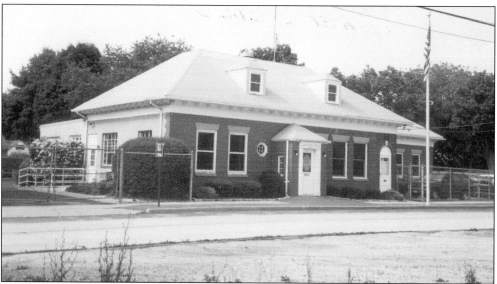

The Sanders Water Company was established in 1909. It took more than a year to dig the first well on the Sanders's property. Eventually, the Sanders Company supplied water through pipes, some of which were wooden, to the Greenlawn Railroad Station and nearly 100 Greenlawn homes. In 1927, the Greenlawn Water Company purchased the Sanders Company's facilities. Today, the Greenlawn Water Company has 16 wells in use that serve a 13-square-mile area. Greenlawn is known for its tasty water, which, over the years, has won many awards.

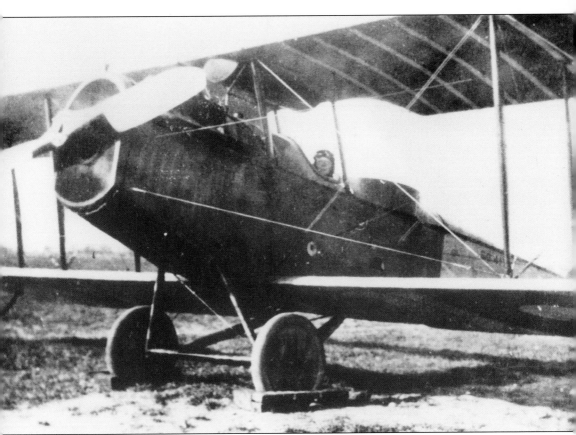

The Aerocraft Factory was built by Fred Gore in 1916. It was located at the edge of a level field, just west of Manor Road between Clay Pitts and Cuba Hill Roads. The entrance was a lane off Cuba Hill Road. Mr. Gore was an inventor who held patents on an idea for a streamlined plane that was to have a single short wing built as part of the fuselage. Many people had faith in his design. It was this plane that Mr. Gore and his crew built in the factory under the watchful eyes of local children, who were permitted to sit on the cat walk and view the progress of work on the floor below. The plane had an unsuccessful tryout, *c.* 1923. To our knowledge, it was the only plane built there. The building burned in 1934, two years after Mr. Gore's death. Pictured here is Henry Shea, age 10, in an early biplane at Brindley Field.

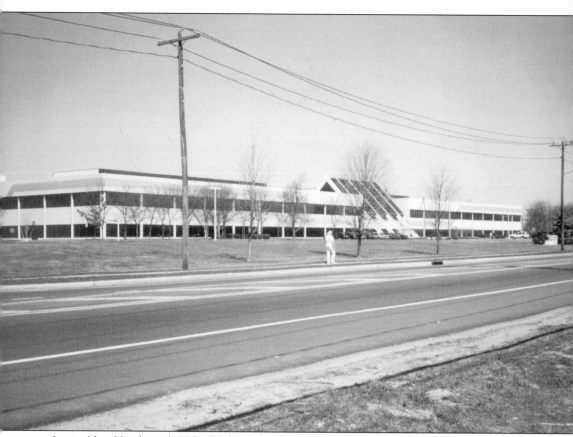

Louis Alan Hazeltine (1886–1964), professor at the Stevens Institute of Technology, electrical engineer, and physicist, invented the Neutrodyne radio receiver in 1922. This was the first radio to achieve wide household acceptance and the predominant type of radio until superseded by the type in use today. Hazeltine Corporation was formed in 1924 to manage the licensing of the Neutrodyne and other patents. The company's early work concentrated on research and development in radio and television, leading to many patented inventions. During World War II, the company developed and manufactured electronic products for the U.S. Department of Defense, including the first electronic Identification Friend or Foe (IFF) system for the United States and its allies.

In 1957, Hazeltine acquired its first facility in Greenlawn on the east side of Cuba Hill Road. The adjacent property was acquired in 1959, and three additional buildings were constructed. In 1970, Long Island operations were consolidated when a new headquarters building was constructed on Pulaski Road. This building was expanded in 1986.

Hazeltine was acquired by Emerson Electronics in 1986, by GEC in 1996, and in 1999 by BAE Systems. At one time, more than 3,000 people were employed, predominantly at the Greenlawn facilities. Today, about 700 people work on the design and manufacture of defense electronic equipment and systems.

Five

TRANSPORTATION

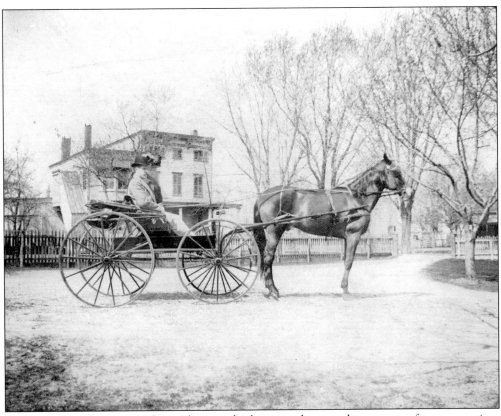

At the turn of the century, horse-drawn vehicles were the prevalent means of transportation. Here, Mr. and Mrs. Davey are shown in their buggy, drawn by their horse, Millie, c. 1890. The general store is in the background.

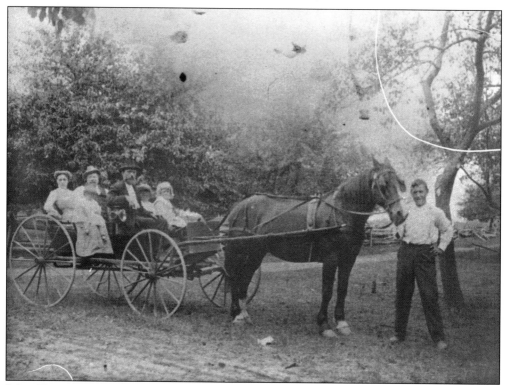

Julius Eppinger poses with his children and relatives in their surrey c. 1908. This photograph was taken in the orchard of the former George William Smith farm, where the Eppingers lived at the time.

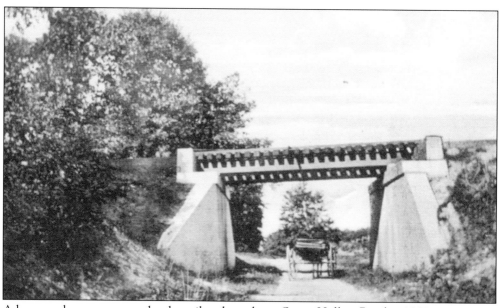

A horse and wagon pass under the railroad trestle on Stony Hollow Road c. 1908.

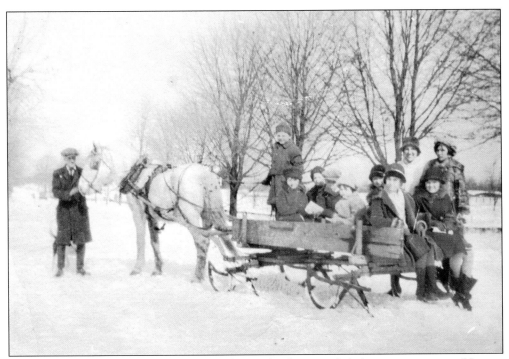

When snow covered the ground, horse-drawn sleighs provided the transportation. Here, a group of Greenlawners board a sleigh on Taylor Avenue to travel to a church function.

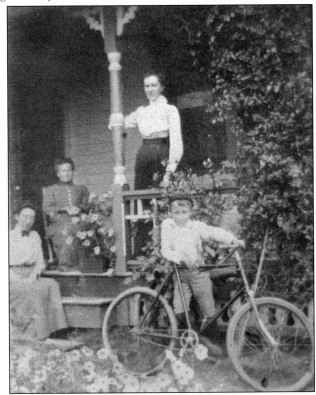

Bicycles were a popular mode of transportation for all ages. A young Van Nostrand lad holds his prized possession as he poses with his family in front of their farmhouse on Stony Hollow Road, c. 1900.

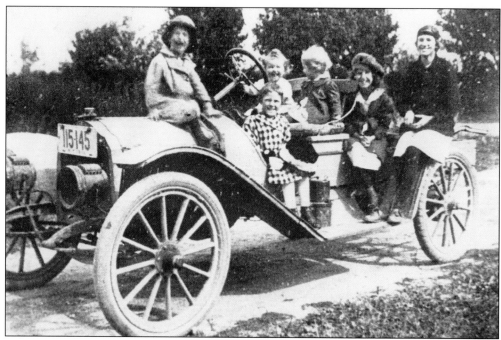

In 1916, it was a treat to go for a ride in a motorcar. Shown are some Greenlawn children in Clarence Sanders's classy automobile.

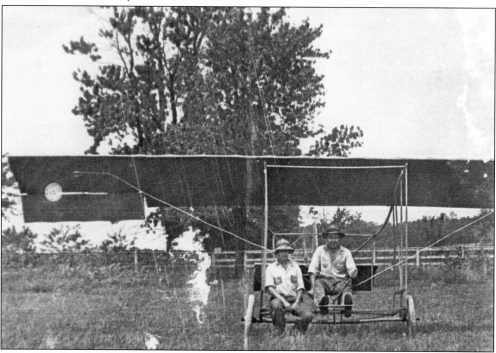

Greenlawn had level open fields, perfect for experimenting with the new flying machines. Harold Gardiner and Walter Eppinger are shown in the glider that they and Herbert Gardiner made in the 1920s. Its flying days were short-lived, however, as the plane met a disastrous end shortly after takeoff.

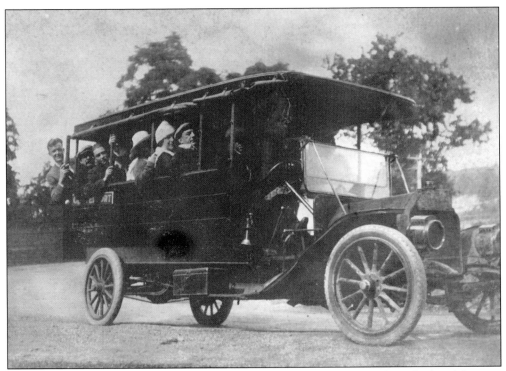

This 1907 postcard shows the Centerport-bound bus leaving the Greenlawn Railroad Station. The bus made regular trips from the station to the hotels and boardinghouses in Centerport, the shore village a mile and a half to the north.

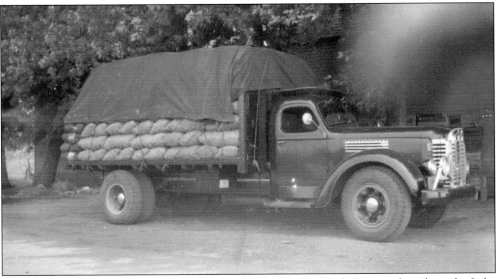

A truck loaded with potatoes is ready to set out for the New York City markets from the Lake Road farm of Leroy Gardiner c. 1938.

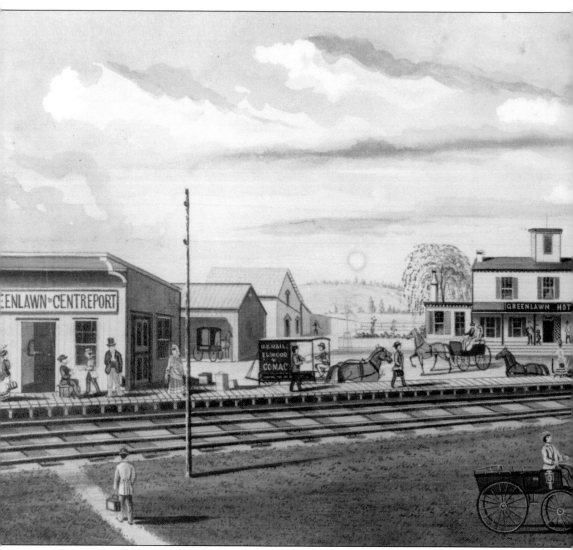

Edward Lange's painting *The Village of Greenlawn, 1880* provides the best available record of the way the hamlet of Greenlawn looked in its early days. The advent of the Long Island Rail Road in 1868 spurred the community's growth; the earliest homes and businesses are clustered around the depot. The farmlands stretch beyond. Lange depicts the action in his characteristic detailed style: the chugging train approaching, passengers getting ready to board, the mail wagon waiting, the horse and wagon stopped at the crossing. Just north of the tracks, the Greenlawn Hotel offers convenient accommodations for debarking passengers. The skylit

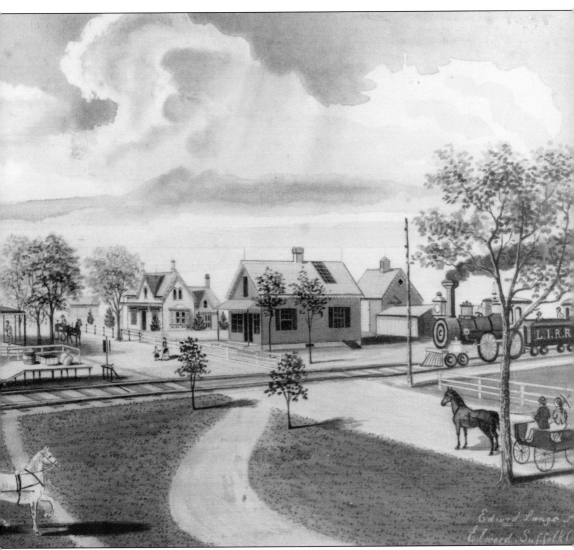

building is probably a residence at this time, but later housed various businesses. The Carpenter Gothic home to the north is the residence of Homer Pierson. The wide dirt road is Broadway. In the foreground, a green lawn extends to the tracks from the general store, not seen in the picture. Perhaps Greenlawn was named for this patch of grass. Lange probably painted the scene from a window of the apartment above the general store.

Edward Lange (1846–1912) was born in Germany and later lived in Elwood, Long Island, where he earned his living as a landscape painter. He received commissions from local landowners to paint their homes and farms. He also painted villages, businesses, and local scenic attractions for commercial and advertising purposes. Sometimes Lange photographed his paintings and sold copies. Lange was probably a self-taught artist, but the carefully executed details in his drawings and the historical accuracy of his renderings provide an important record for historians.

109

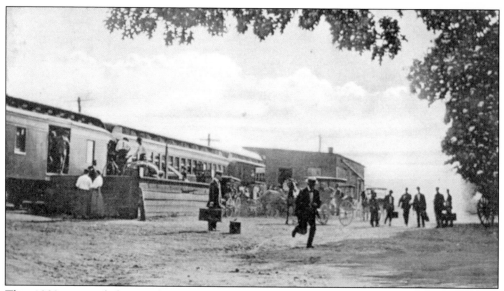

This 1908 postcard shows a busy Greenlawn Railroad Station with passengers arriving and heading for waiting carriages.

During the summer of 1895, the Long Island Rail Road scheduled five trains each weekday and several weekend trains between Greenlawn and Brooklyn or Long Island City, from which ferry service to Manhattan was provided. There was no direct connection to Manhattan until 1910, when the East River Tunnel and Penn Station were completed.

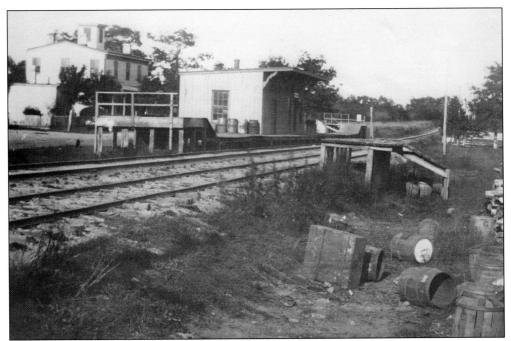

This is Greenlawn's first Long Island Rail Road depot with its freight loading platform. In those days, the LIRR offered special freight services. Farmers could leave cans of milk and crates of live chickens or vegetables on the platforms. These would be picked up by railroad workers and transported to dealers in the city, and the empty crates would be returned to the platform. This first station was located on the north side of the tracks, west of Broadway. Built in 1868, it was quite dilapidated by the early 1900s. No one was sorry when the "whole unbeautiful structure" burned down on September 29, 1910.

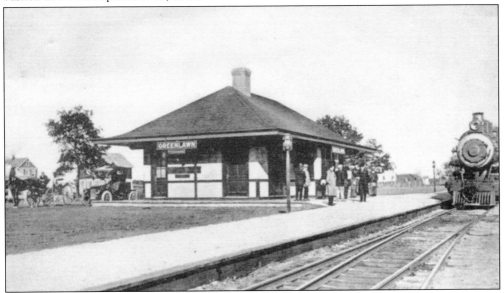

When the new Greenlawn Railroad Station was built in 1911, it was relocated east of Broadway, across from the firehouse. In this c. 1918 view, a group of passengers and the livery service await the approaching westbound train.

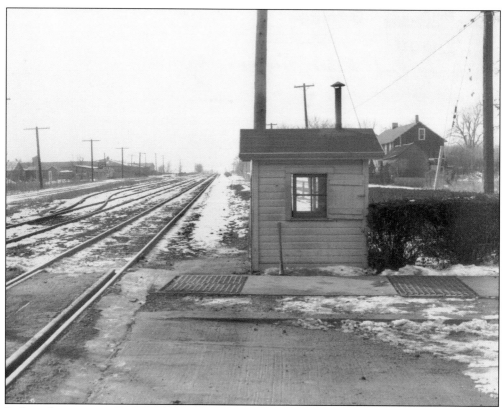

Before there were gates at the crossings, a man was hired to stop traffic when a train approached. Between trains, he rested in the hut. This photograph was taken in 1944 at the Broadway crossing.

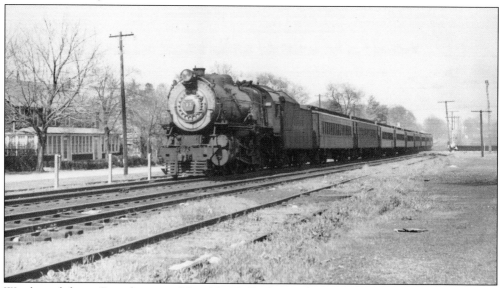

Westbound from Greenlawn on May 11, 1947, this G-5 No. 31 4-6-0 locomotive built by Juneata in 1928 is pulling a nine-car train. The train ran from Port Jefferson to Jamaica only on Sundays and holidays.

Six

THE PEOPLE

Bonnie Brehme and Virginia Nichols practice the "Lollipop Dance" in front of the Wightman farmhouse.

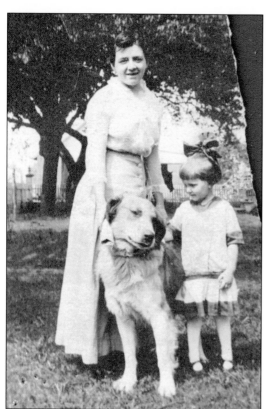

The little girl pictured with her dog is Elizabeth Gardiner, the granddaughter of Alexander Gardiner. Her companion is Rose Robinson. Elizabeth later married Henry Shea.

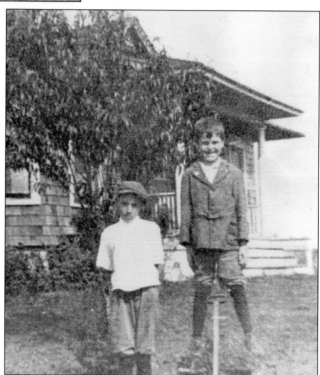

Gilbert Brush and Clinton Wheeler stopped playing with their wagon to pose for this 1917 snapshot on Brush Lane.

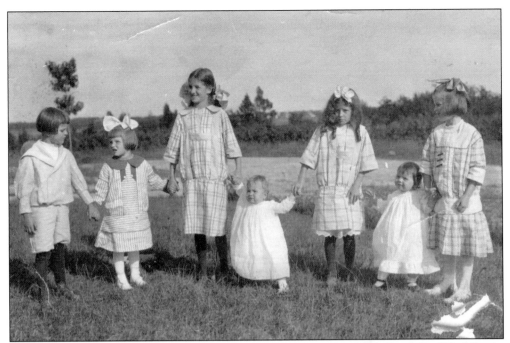

Greenlawn children in their Sunday best are, from left to right, Selah Brush Jr., Ethel Brush, Dorothy Rae, Lloyd Rae, Lorna Rae, Margaret Hendrie, and Helen Brush.

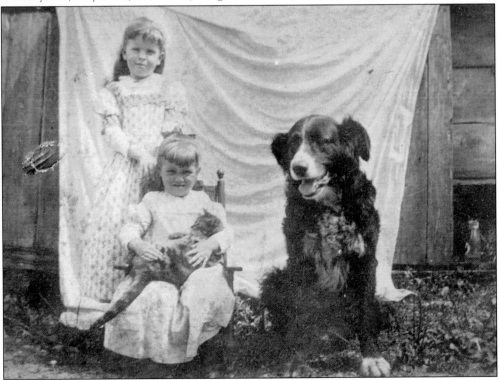

Children Ella and Hazelle Kissam are pictured with their dog, Dash, and Binnie the cat. The year is 1896.

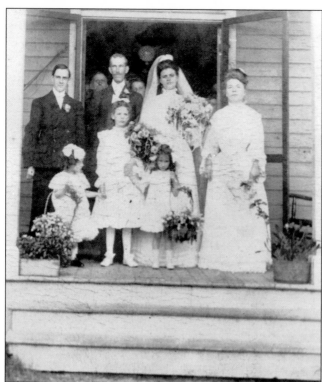

The wedding of Selah Brush and Angeline Smith on June 8, 1904, was held at the home of the bride's parents, Mr. and Mrs. Samuel Smith, on Cuba Hill Road. Attendants include Maude Gates and Edwin Smith and flower girls Loretta Gardiner, Cora Carter, and Muriel Smith.

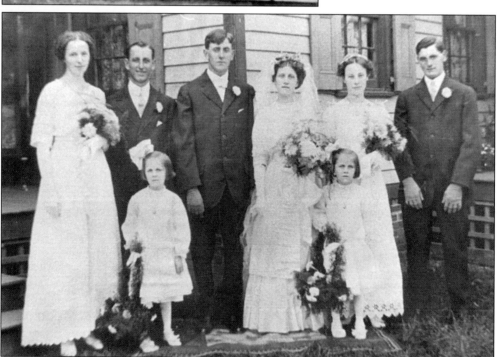

Posing for a wedding portrait on September 20, 1911, are the bride and the groom, Daisy Gardiner and Leroy Tilden, with Mr. and Mrs. Charles Gardiner, left, and Florence James and Raymond Tilden, right. In front are Ella and Elsie Gardiner, the twin sisters of the bride.

This Ladies' Sewing Circle meets at the home of Mrs. Munger c. 1899. Pictured, from left to right, are Mabel Ketchum, Evvy Smith, Addie Conklin, Bertha Gates, Agnes Kissam, Sadie Hogan, Ida Kissam, and Mrs. Munger.

Resting after Thanksgiving dinner in 1899, are, from left to right, Ed and Frank Flessel, Lou Brush, Fanny Flessel, Carrie and Elbert Soper, Grace, Carrie, and Annie Flessel.

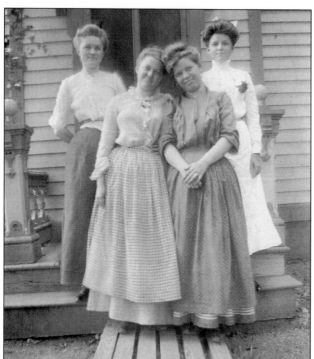

The four daughters of Seabury Smith and Josephine Kissam are pictured in front of their home on Broadway c. 1910. They are Ida, Hazelle, Agnes, and Ella.

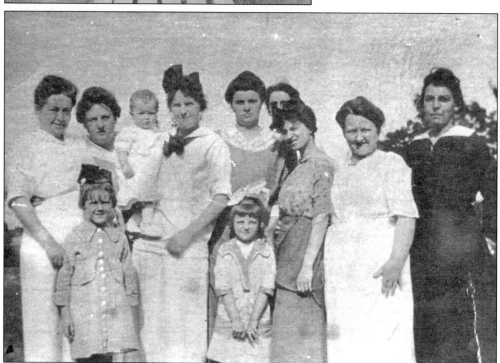

This group picture of Greenlawn women and their daughters was taken in 1916. Shown, from left to right, are Minnie Ellis, Maude Gates, Mabel Sanders holding her daughter Jean, Lina Brush, Mazie Rae, Edith Smith, Mae Gurney, and Anna Smith. The children in front are Marie Ellis and Ethel Brush.

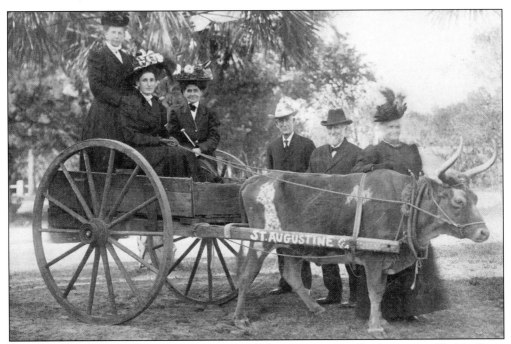

Greenlawn friends pose for a souvenir picture while on vacation in St. Augustine, Florida. From left to right, they are Emily Brush, Mazie Rae, Phoebe Smith, Joseph Brush, Charles D. Smith, and Annie Brush Rae.

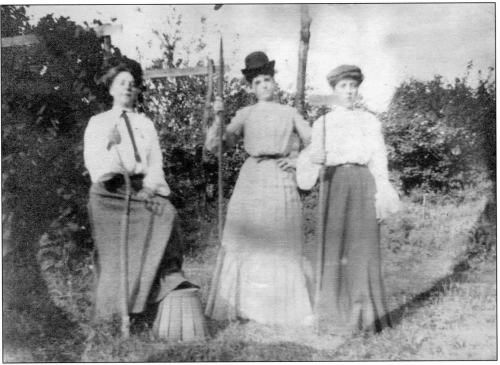

These three young Greenlawn ladies are playing farmer; from left to right, they are Maude Gates, Grace Pierson, and Grace Flessel.

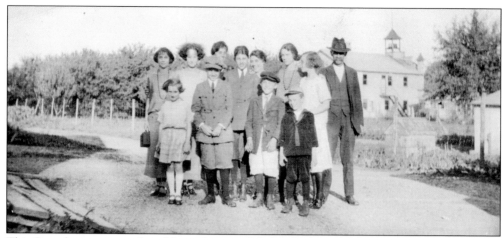

This Greenlawn group gathered for a photograph behind Ed Smith's house in 1923. Shown, from left to right, are the following: (front row) Rita and Albert Miltner, Arthur Smith, and Lawrence Smith; (back row) Helen Smith, Lorna Rae, Florence Luhrs, Ed Smith Jr., Louise Miltner, Selma Smith, Elsie Smith, and Edward Smith Sr. The firehouse can be seen in the background.

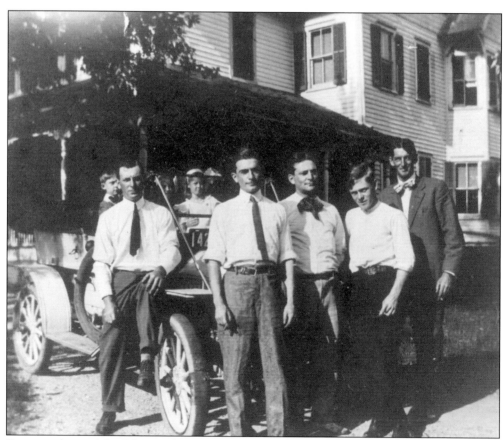

Posing in front of the Ed Gates home on the corner of Broadway and Boulevard are, from left to right, Ira Lewis, Ray Gates, Henry Gates, Elliot Smith, and George Rae.

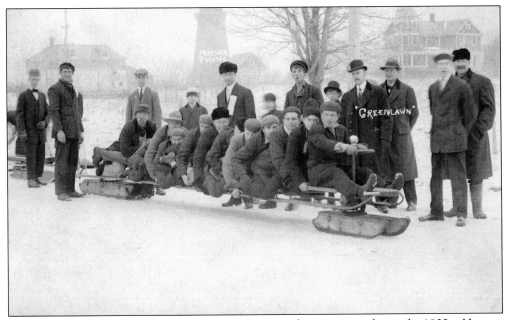

Bobsled racing was a popular sport among men and women in the early 1900s. Here, a Greenlawn team prepares to race.

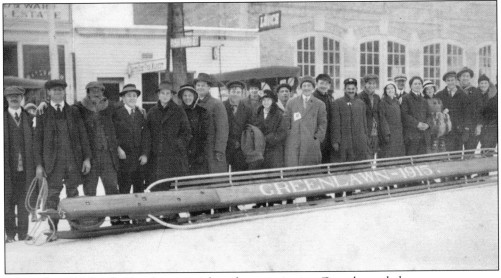

Pictured in 1915 is this local group with perhaps a winning Greenlawn sled.

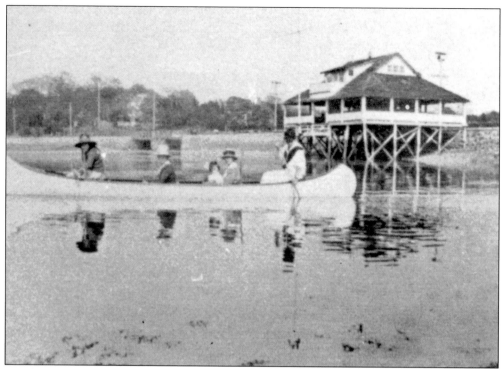

Just down the hill from Greenlawn, Centerport Harbor was a fine place to swim, fish, or boat. Here, Florence Baker and her four daughters enjoy a canoe outing.

Fishing from the dock at Centerport Harbor was a perfect way to spend a summer afternoon.

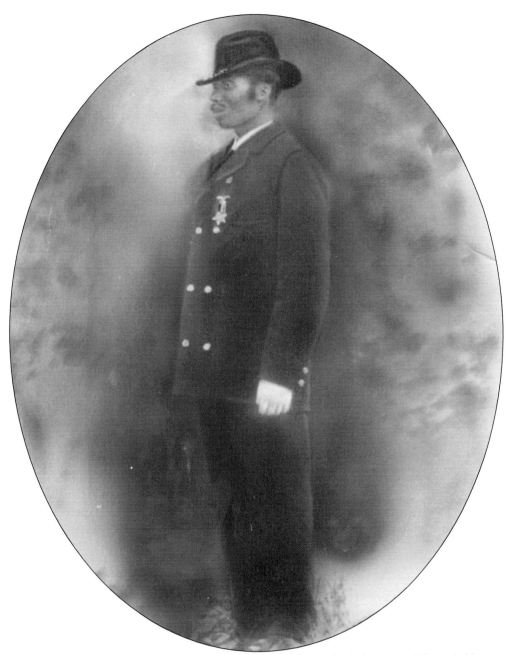

Samuel Ballton (1838–1917) came to Greenlawn with his wife, Rebecca, and their children in 1873. He was a Civil War veteran who had escaped from slavery, joined a Northern regiment, and saw action in many battles. In Greenlawn, Ballton worked as a farmer, sharecropping for a time with Alexander Gardiner. He was a successful grower of pickles and also a successful buying agent for a Boston pickle house. Always ambitious and open to new business ventures, Ballton went into real estate and home building. His homes on Smith Street, Taylor Avenue, and Boulevard were well designed and sturdy; they are still occupied today. Samuel Ballton, like Alexander Gardiner and John Deans, was a promoter of Greenlawn and worked hard to support its progress.

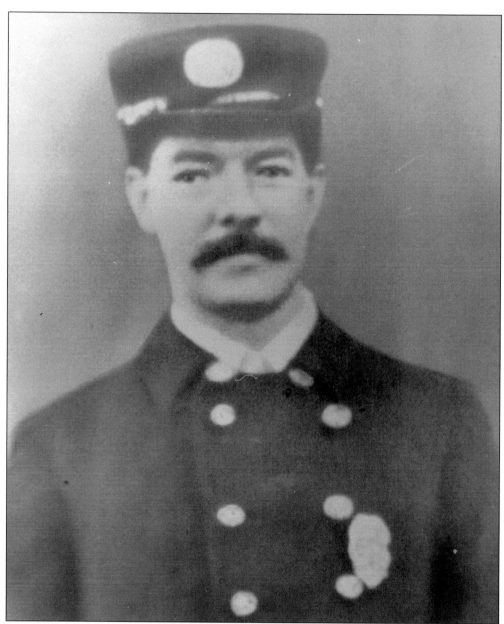

John Deans (1872–1938) was born in Manhattan and moved to Greenlawn when he married Elizabeth Breen in 1899. He purchased the general store from his uncle, John Lawson. Business prospered, and in 1910 he built a new, modern store, which he called the Greenlawn Store, on the corner of Broadway and Smith Street. Deans was known as the unofficial mayor of Greenlawn because he worked tirelessly to benefit and improve the community. He was a charter member of the Columbia Hook and Ladder Company, its second fire chief, a school trustee, a justice of the peace, and a trustee of the Greenlawn Presbyterian Church. Deans knew everyone and, for years, sent birthday cards to every child in Greenlawn. He had the foresight to clip newspaper articles about Greenlawn happenings. Covering the period from 1905 to 1938, this scrapbook has preserved the history of Greenlawn's people and events; it is a valuable document that is housed in the archives of the Greenlawn-Centerport Historical Association.

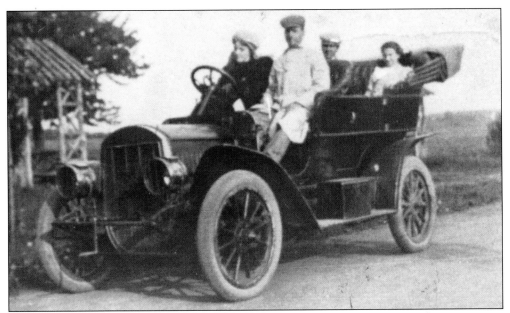

The Sanders family—Mr. and Mrs. Alonzo Sanders, Burt, Clarence, and Edith—moved to Greenlawn in the early 1900s. They owned extensive property on the west side of Broadway from Wyckoff Street north beyond Alvord Court. The family owned and operated the Sanders Water Supply Company, the most important strawberry farm in the area, the Sanders Real Estate and Building Construction Company, and later, insurance and printing businesses. This 1912 photograph shows Mr. and Mrs. Clarence E. Sanders in the front seat of his Chalmers touring car. In the rear are Burt and Edith Sanders, the brother and the sister of Clarence.

Burt Sanders was a talented and well-known illustrator whose cartoons and illustrations with commentary appeared continuously between 1900 and 1915 in prominent comic weeklies and popular magazines such as *Judge* and *Life*. During this period, Burt maintained a studio in Brooklyn. He never married, and the income from his work financed his family's business ventures. Today, Burt's work is highly collectible. He is recognized as one of the great artists of the "Golden Age of Illustrators." This cartoon, which appeared in *Life*, is an example of his work. The caption reads, "A couple smashed tires doesn't delay Smith. Not much! Smith hasn't forgotten how to ride a bicycle yet."

Norman Baker (1885–1968), who designed the Broadway School in Greenlawn, was a prominent architect whose work included the design and supervision of construction on major landmarks, including Rockefeller Center, the Daily News Building, the UN, Lincoln Center, and Oheka Castle. Personally, he favored Colonial-style architecture; he also designed and built many buildings and homes in this style on Long Island. His ideas about adapting Colonial style to 20th-century homes were incorporated in his book *Early Houses in New England*, published in 1967. His wife, Florence Baker, was a noted landscape designer. A founder of the Huntington Roadside Committee, she was active locally and nationally in community planning, beautification projects, and conservation efforts.

Highover, the Arbutus Road home of the Baker family began in 1912 as a small cottage that had been Mr. Baker's office at the Otto Kahn estate where he was supervising architect. Mr. Baker expanded the house over a period of 40 years into a very unique home. Its many unusual features included a fireplace made of stones collected by the whole family from the property, a cabinet made from an old Brush farm door, and a floor of quarry tile brought over from Wales.

Russell B. Brush (1905–1988) was one of five children of Selah and Angeline Smith Brush. He was raised on the Old Field Road family farm, first settled by his grandfather, Frederick Brush, in 1867. Russell worked in the import-export business, but his avocation was geneaology and local history. An organizer and charter member of the Greenlawn-Centerport Historical Association, he served as its first president and, thereafter, as a member of the board. Photographs and artifacts from old-timers, gathered by Russell, formed the core of many of the association's collections. His memory was legendary; for years, he was the major source of information relating to the people, places, and events in Greenlawn's past.

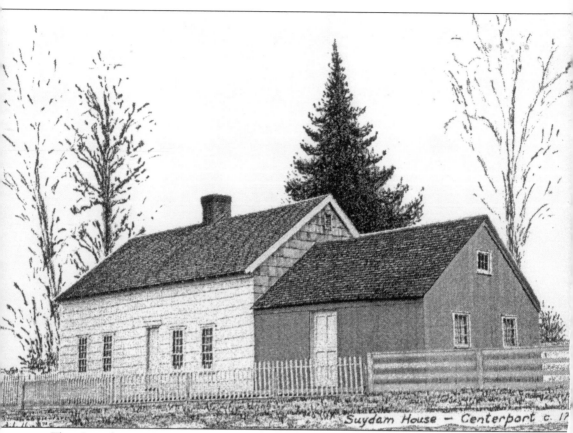

Suydam House — Centerport c. 17

The Greenlawn-Centerport Historical Association is a small, vital nonprofit organization dedicated to researching, collecting, and preserving the history of Greenlawn and Centerport—two hamlets on the north shore of Long Island. Historically interdependent, the two communities today share a school district, a library, and our historical association.

The office and research facility of the organization have been housed in the Harborfields Public Library since 1976. Owning a historic house was a dream realized in 1989, when the association was able to purchase the 1730 Suydam Homestead in Centerport. The house has been restored and the Beierle Barn Museum erected on the property.

In 2003, the association inherited the three-acre Smith-Gardiner Farm (now known as the John Gardiner Farm) from Herbert Gardiner. In addition to the existing farmhouse and several outbuildings, a large Gardiner barn was moved to the farm. It houses a welcome center and gallery as well as an event space. Educational programs, hands-on exhibits, and demonstrations for school and community groups are now offered at both historic locations.

A growing collection of photographs, documents, genealogical information, and written histories relating to Greenlawn and Centerport are maintained and made available for research. It is these special resources that the authors have used in preparing this book for the Greenlawn-Centerport Historical Association.